Wildlife
Photographer
of the Year
Portfolio 25

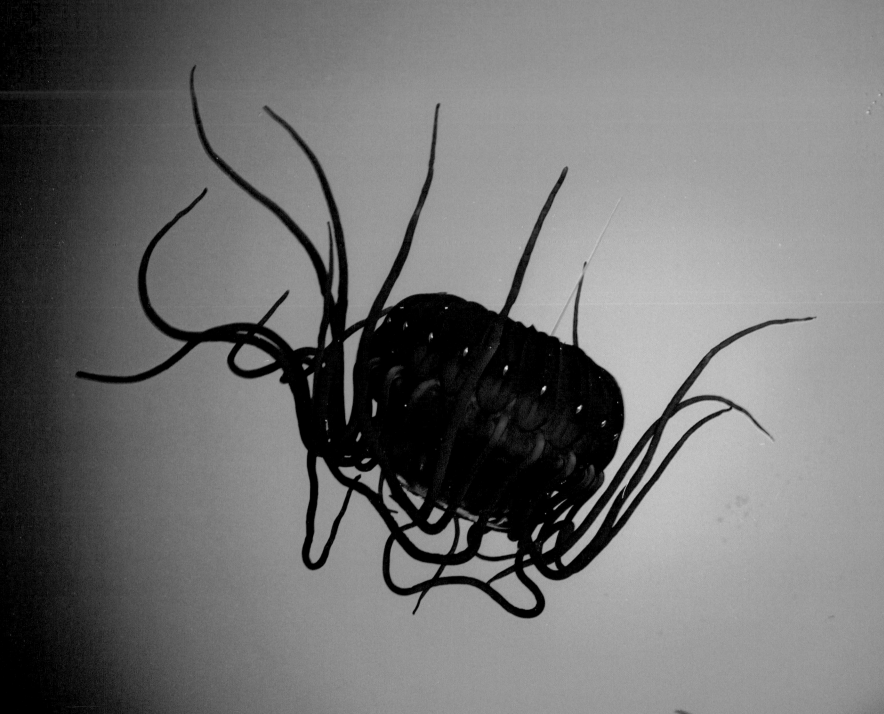

Wildlife Photographer of the Year

Portfolio 25

Published by the Natural History Museum, London

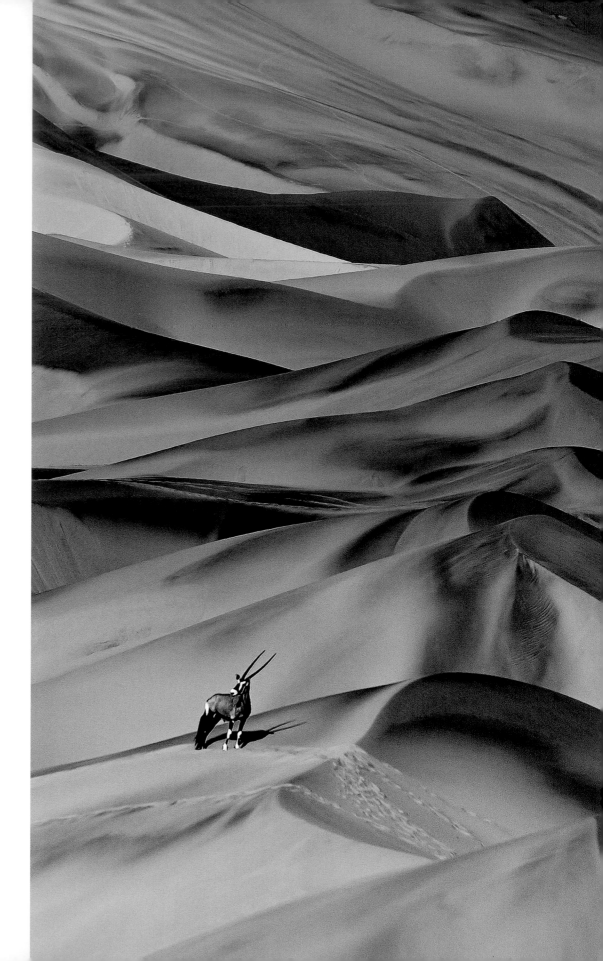

First published by the Natural History Museum,
Cromwell Road, London SW7 5BD
© The Trustees of the Natural History Museum,
London, 2015
Photography © the individual photographers 2015

ISBN 978 0 565 0 93778

A catalogue record for this book is available from the
British Library.

Editor: Rosamund Kidman Cox
Designer: Bobby Birchall, Bobby&Co Design
Caption writers: Tamsin Constable and Jane Wisbey
Colour reproduction: Saxon Digital Services UK
Printing: Printer Trento Srl, Italy

Contents

Foreword

Last year saw the celebrations for the 50th anniversary of the Wildlife Photographer of the Year – the longest running and most prestigious wildlife photography competition in the world. I bought my first camera just a few years after its inception. I was 22 and had just graduated with a degree in biology. It was 1968, and either I was heading to Vietnam or back to college to do postgraduate studies in zoology. Luckily, I was never called up for the army and was able to go to graduate school.

I knew almost nothing about photography, but I really wanted to document the beauty of the Platte River in Nebraska, where I had grown up, and the threats facing it. I was disappointed that no painter, film-maker or photographer had captured either the landscape or the incredible spring migrations of half a million sandhill cranes and 15–20 million waterfowl that use the Platte as a staging area before continuing their long flight to the far north. The Platte was slowly going dry from the diversion of its headwaters in Colorado and Wyoming by boom cities such as Denver and the many dams and farmland-diversion projects. The river no longer flooded in the spring, scouring the channel of encroaching vegetation with massive sheets of ice. And the once incomparable riverine landscape, whose banks were home to beavers and bison, pronghorn and plains grizzlies, was rapidly becoming a woodland.

The first step to achieving my goal was acquiring my first camera. On his way back from Vietnam, my best friend bought me at the military store a much-discounted Asahi Pentax SLR, with 400mm, 300mm, 135mm and 50mm lenses. Then at graduate school, I discovered the work of great nature artists and photographers.

My mentor and adviser was Paul Johnsgard – an internationally known ornithologist who had studied waterfowl behaviour at Slimbridge, England, under the legendary Sir Peter Scott. His passion for birds and photography grew on me, and he infused me with a greater knowledge of animal behaviour. I studied art history and many of the world's great bird artists such as Sweden's Bruno Liljefors. Paul gave me Eric Hosking's photographic biography *An Eye for a Bird,* and I began to discover the work of artists such as Louis Agassiz Fuertes, and Andrew Wyeth and, of course, great photographers such as Ansel Adams, Edward Weston, Ernst Haas and Eliot Porter. Seeing their work drove me not only to document wildlife and the natural world but to do it with artistic vision and purpose.

I was naïve enough, thank God, to think wildlife photography could be considered fine art. But I learned during those early years and even until quite recently that, though photography in general has nearly always been considered an art form, neither wildlife painting nor wildlife photography, with very few exceptions, meets the criteria of the art-museum world for fine art. Had I known the battle ahead I may have stuck with the norm at the time – just doing trophy animal shots. But how boring that would have been.

I believe the Wildlife Photographer of the Year competition has helped bring the genre up to the level of receiving that highly debated accolade. It's a prize worth the effort. However it can't be assumed – relatively few images make that cut.

I was fortunate enough to have won the Wildlife Photographer of the Year Award in 1994. So it was a wonderful return journey for me to be back at the Natural History Museum as one of this year's panel of judges. The task, though, was daunting. The digital age has seen a massive evolution in the world of photography, making it accessible to many. Indeed, this year there were more than 42,000 entries representing photographers from every corner of the Earth. But the vision needed to make a picture special is in much scarcer supply than technique or opportunity.

To have both purpose and vision requires becoming intimate with a place and subject. It means spending time considering what you are trying to achieve and how to get there. There is no formula or blueprint. Create your own vision, style and niche. The rewards will be great.

Thomas D Mangelsen
judge, Wildlife Photographer of the Year 2015

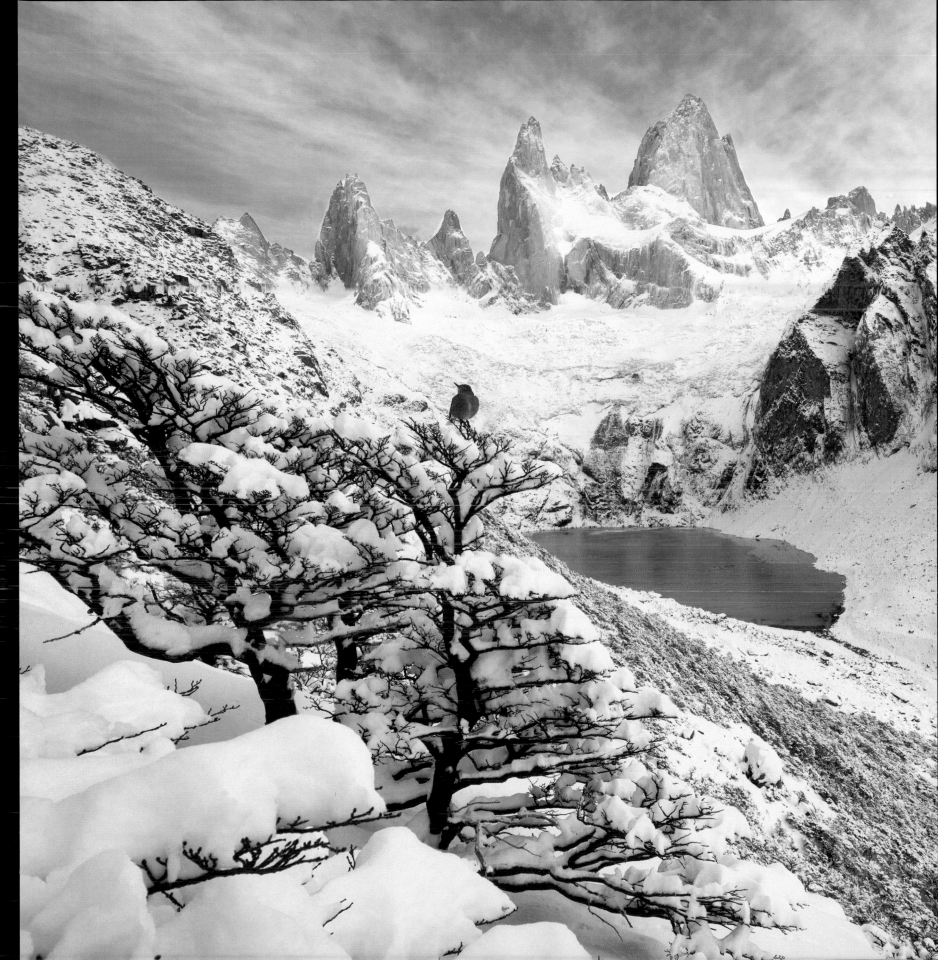

The Competition

For half a century, this competition has showcased the best in wildlife photography – indeed, has both charted and changed the development of wildlife photography itself. The photographers who have featured in it have included both the leading professionals of the day and talented amateurs. Today it remains the world's largest and most prestigious competition championing images of nature and natural environments.

Over the years, the increase in number of entries has paralleled the increase in photographers and accessibility of equipment but also, most notably, the growth in digital photography in the past decade, resulting in an annual entry now exceeding 40,000. An international panel of judges selects the final 100 entries from a range of categories encompassing all aspects of wildlife and environmental photography, with separate categories for young photographers. There are awards for portfolio and story collections, but the overall award is given for a single image. This is selected from all the category winners and carries with it the coveted title Wildlife Photographer of the Year. An equivalent award is also given to a young photographer.

Over the past few years, the advances in technology have been huge, allowing the capture of the fastest of movements in the lowest of light. The judges, though, are looking for innovation beyond the technical – for new observations and new ways of seeing the natural world, and also for storytelling. They choose the images principally for their aesthetic qualities, and they don't know the identity of the photographers or the full stories behind their creation – the stories that you will read here.

No manipulation of photographs is allowed beyond in-camera settings and digital processing according to strict rules. Subjects must be wild and photographed in the wild, unless the picture is meant to illustrate an ethical or conservation issue. Just as important is the welfare of the animal subjects, and their manipulation for photography is strictly forbidden. The overall aim is to keep the artistry to different ways of seeing nature and to show only pictures that are truthful to nature.

The collection is published worldwide (which includes many international editions of this book). It also forms a major exhibition that goes on display at London's Natural History Museum and also travels the world, exhibited in European countries, North and South America and as far away as Australia and China.

This year's collection represents the work of more than 75 photographers from more than 20 countries, with different styles, skills and specialities. All, though, share a passion for the natural world. Through the exposure of their work to an audience of many millions, the competition provides a showcase for both established and developing talent and an inspiration to photographers starting out. But it also serves to inspire an audience of many millions to marvel at and value the importance of the truly glorious nature of life on Earth.

The call for entries runs from December 2015 to February 2016. Find out more at www.wildlifephotographeroftheyear.com

Judges

Sandra Bartocha (Germany), nature and fine art photographer

Stella Cha (USA), creative director, The Nature Conservancy

Paul Harcourt Davies (Italy), nature photographer and author

Kazuko Sekiji (Japan), curator, Tokyo Metropolitan Museum of Photography

Thomas D Mangelsen (USA), photographer

Kathy Moran (USA), senior editor for natural history, *National Geographic* Magazine

Dr Alexander Mustard (UK), underwater photographer

Thierry Vezon (France), nature photographer

CHAIR

Lewis Blackwell (UK), author and creative director

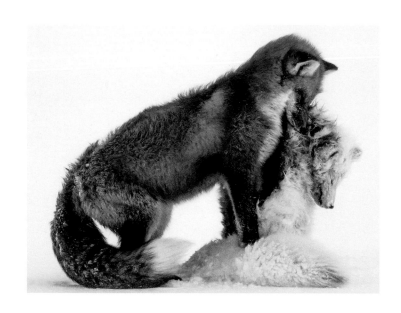

The Wildlife Photographer of the Year 2015

The Wildlife Photographer of the Year 2015 is **Don Gutoski**, whose picture has been chosen as the most striking and memorable of all the entries in the competition.

Don Gutoski

Brought up in the Canadian countryside, Don has had a passion for wildlife and photography since he was a teenager. Though he works as an emergency-ward doctor, he spends all his spare time photographing wildlife, in particular animal behaviour, both in wilderness regions of Canada and overseas. He lives in southern Ontario, surrounded by the 40-hectare (100-acre) wildlife reserve that he's created.

The Wildlife Photographer of the Year 2015

A tale of two foxes

Don Gutoski

CANADA

From a distance, Don could see that the fox was chasing something across the snow.
As he got closer, he realized it was an Arctic fox, and by the time he was close enough
to take photographs, the smaller fox was dead. Don watched for three hours from
the tundra buggy as the red fox fed on the carcass. The light was very low, and it was
−30°C (−22°F), which meant Don needed to keep both the camera and his fingers
from freezing. Finally, having eaten its fill, there was a moment when the fox paused
to regrip the skin before starting to drag away the remains to cache for later. It was
then that Don took his winning shot. The drama was enacted in Wapusk National Park,
near Cape Churchill in Canada. Increasing temperatures in the Arctic have allowed the
range of the red fox to extend northward. Both species of fox hunt small rodents, in
particular lemmings, but where the ranges overlap, the red fox has been recorded as
a predator of Arctic foxes as well as a competitor for food. But few actual kills by red
foxes have been witnessed, probably because the two species normally avoid each
other. As climate change causes the tundra to warm and allows the red fox to move
further north, it's likely that conflicts between the two will become more common.

Canon EOS-1D X + 200-400mm f4 lens + 1.4x extender at 784mm; 1/1000 sec at f8; ISO 640.

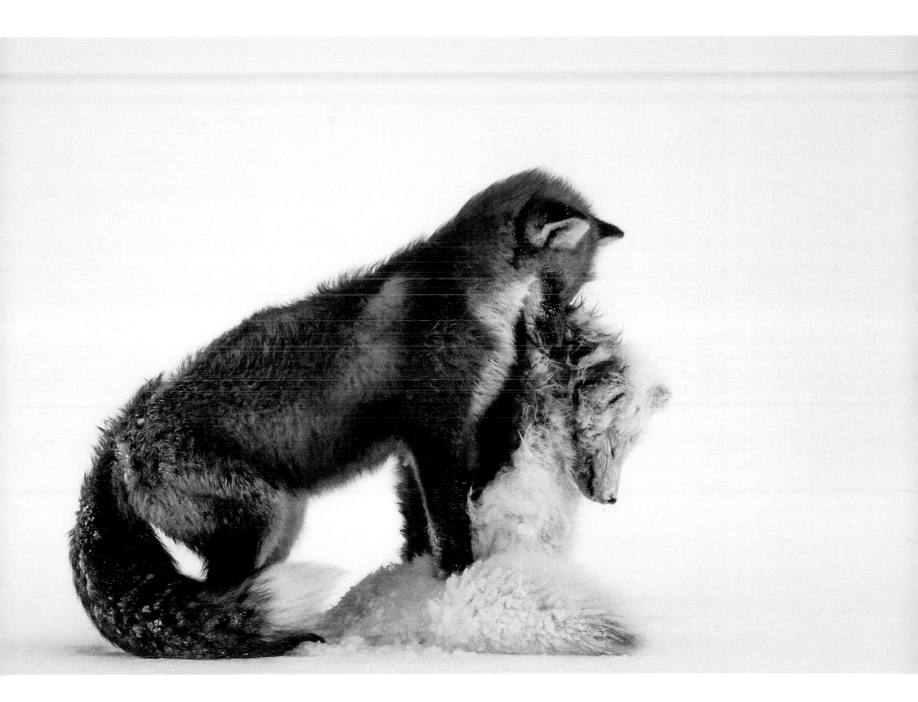

The Wildlife Photographer of the Year Portfolio Award

Audun Rikardsen

NORWAY

Raised in a fishing community in northern Norway, Audun has always been fascinated with the Arctic coast – its culture and its wildlife, both above and below water. He started taking photographs in 2009, concentrating on the wildlife in the region of Tromsø, where he now lives. A professor of biology at the University of Tromsø, he brings his fieldwork experience to his photography. He has been the Norwegian and Nordic Nature Photography Champion several times, the Arctic Photographer of the Year and Nature's Best Grand Champion. For Audun, photography is about recording great moments and showing others the fascination of the natural world, in the hope that it will inspire them to care about nature conservation.

By the light of the moon

At night, in a scene lit by the moon and the northern lights, a brown trout hangs in the shallows of a river in northern Norway. After spending the summer at sea, it has returned in late autumn to spawn in the river where it hatched. The trout gathering in the upper reaches create nests in the gravel into which they release their sperm and eggs. They often do this at night to avoid predators such as eagles, which may gather along the banks to feast on the migrating fish. Audun had worked on this river for several years and knows it intimately – exactly when the fish congregate and which bends of the river they favour. He also knows how they behave and how to approach without scaring them. But the technical challenges of the shot involved several months of planning and the design of a special housing and underwater flash set-up, as well as a system that would allow him to alter the focus and aperture within a single exposure. That he got the image exactly as he visualized it was a dream come true.

Canon EOS-1D X + Samyang 14mm f2.8 lens; 35 sec at f22 and at f5.6; ISO 640; x2 Canon 600 strobes; home-made underwater housing.

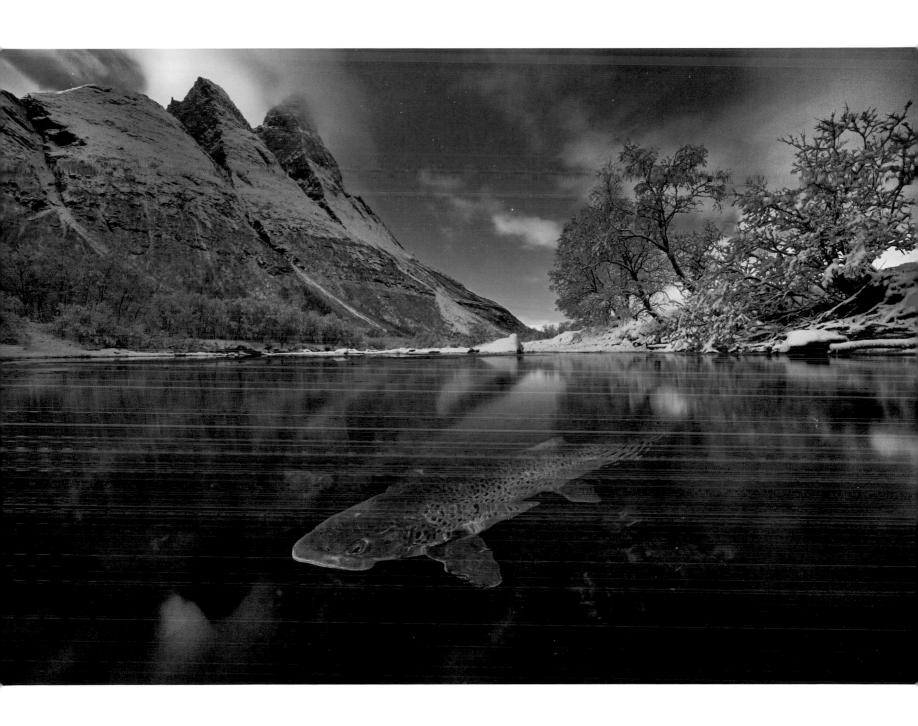

Splash-time with Buddy

Audun had mixed feelings about Buddy. Partly he hoped that this young male walrus would stop hanging around the remote beach off Tromsø and join its kin farther north. The first two weeks after he and his friends found him, they kept their distance, but their relationship really began one day when the walrus approached Audun, who was lying in the shallow water, and began to gently stroke his hand with his sensitive whiskers. For one-and-a-half months, Audun regularly visited him. 'I got to know his personality. He would talk to me, and I could tell whether he was grumpy or if he was having fun, teasing me by splashing water at me, as he's doing here on a midnight summer swim – the last time I ever saw him. Once, he put one flipper around one of my legs, hooked his tusks around the other leg, and tried to drag me out to play in deeper water.' Buddy did eventually leave, on the day Audun returned from a month's field trip, half an hour too late to see him for the last time. 'I still miss him,' says Audun.

Canon EOS 5D Mark III + 8-15mm f4 lens at 15mm; 1/160 sec at f10; ISO 2500; Canon 600 flash; Aquatech housing.

Deep sleeper

Late one evening, Audun received a call telling him that something strange was bobbing around in a fjord outside Tromsø. It was 1am but midsummer in northern Norway and so the sun was above the horizon, illuminating the mountain scene. Audun's house was close to the jetty, and it didn't take long for him to launch his dinghy and investigate. What he found was a visitor from the high Arctic – a bearded seal fast asleep, its throat puffed up with air and its flippers tucked in, perfectly balanced for floating. It must have been asleep for a while because its whiskers above the surface had dried into curls. Having forgotten his flash arm, Audun had to hold the camera in one hand and a flash in the other, the cable in his mouth. Briefly, the seal opened its eyes to gaze at him, then nodded off again. Bearded seals are often trusting of humans, but a scar on its throat revealed a more sinister encounter in its past, perhaps with a boat propeller, a fight with another seal or even the claw of a polar bear.

Canon EOS 5D Mark III + 8-15mm f4 lens; 1/160 sec at f10; ISO 1000; Canon 600 flash; Aquatech housing.

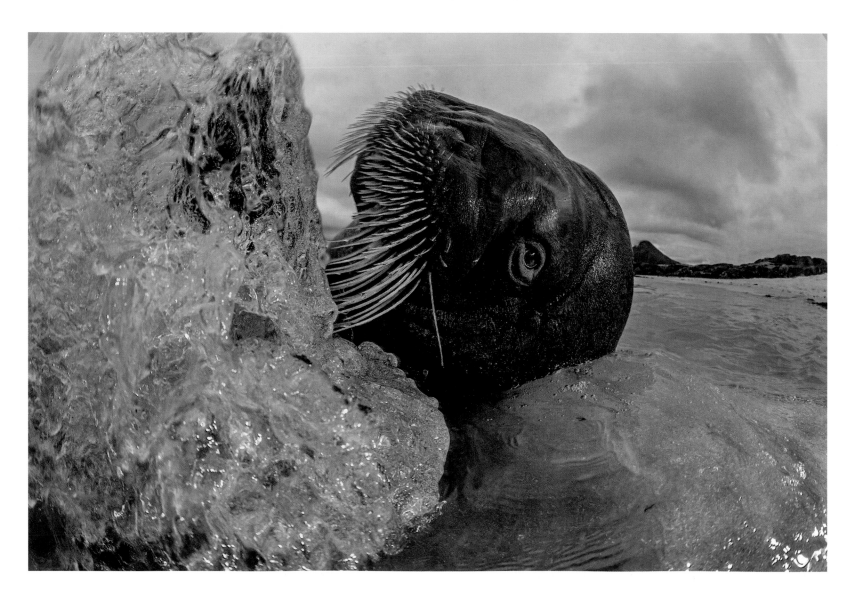

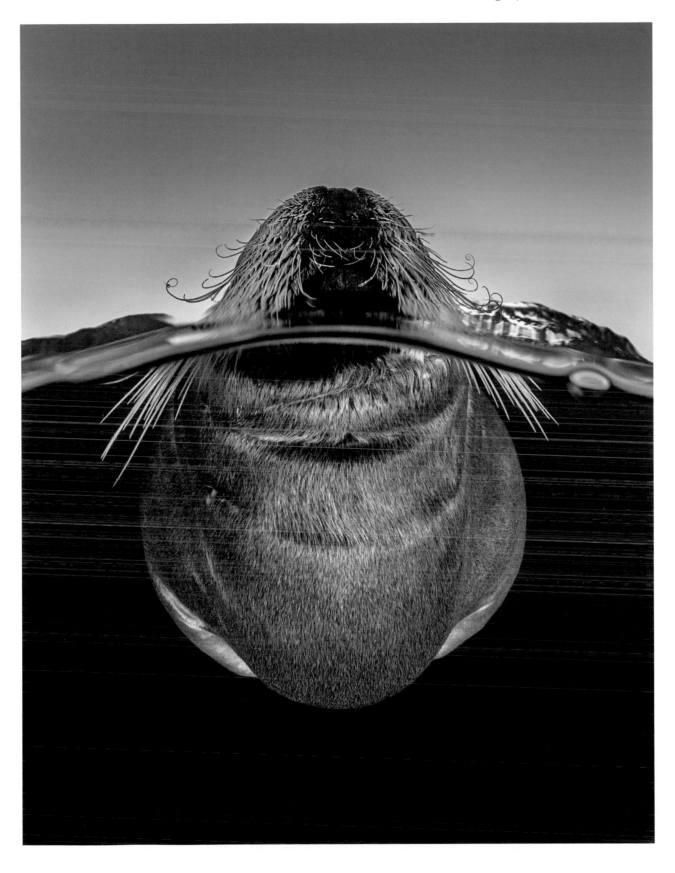

The last rays

In the water, Audun could hear the killer whales calling to each other as they herded up a shoal of herrings. It was mid-November, and the herrings had migrated into a fjord near Tromsø, pursued by the whales. The sun was just on the horizon, striking the waves at an angle so that the light cracked through the surface. It was the time Audun had been waiting for. With his camera extended on a pole, the settings pre-adjusted, he was ready. The moment came when the lead male approached to check him out, moved slowly past and then turned, angled towards the light, and took a breath. 'It was a few magical seconds when everything fell into place.' The next day, the sun finally dropped below the horizon, not to reappear above the mountains until February.

Canon EOS 5D Mark III + 16-35mm f2.8 lens + ND 0.6 graduated filter; 1/200 sec at f6.3, ISO 2000; Aquatech housing.

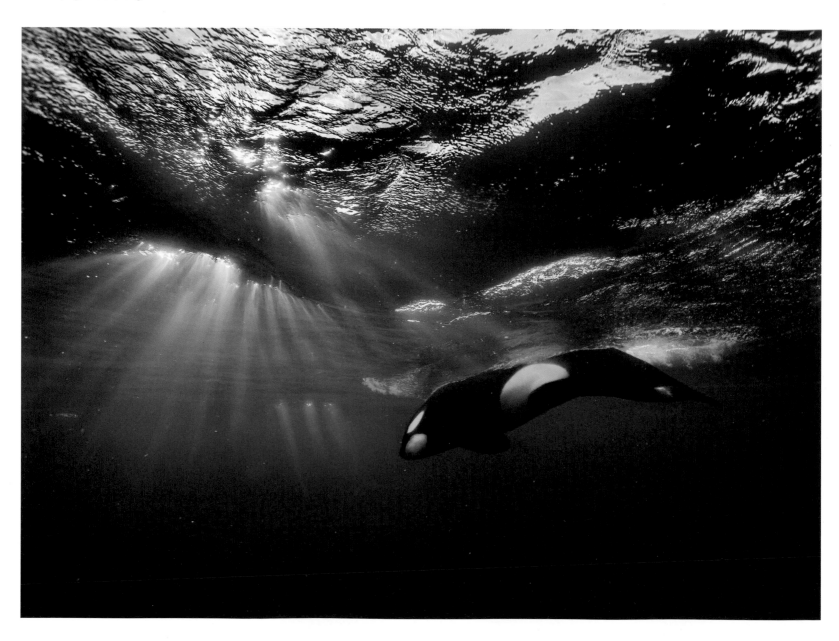

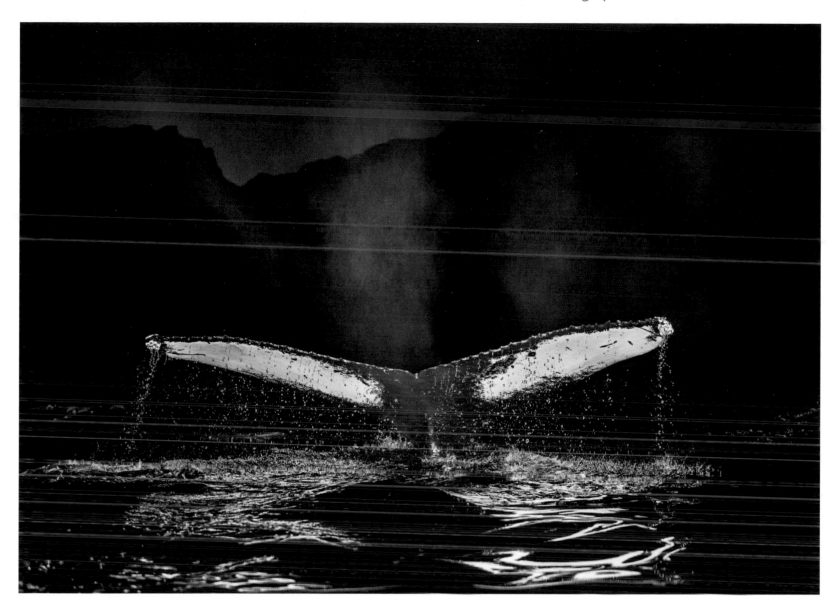

Dark dive

In recent years, herring shoals have started to overwinter in a fjord near Tromsø in northern Norway. And where they go, humpbacks follow. They hunt herrings by corralling them against the surface and taking huge mouthfuls out of the swirling shoal. Audun's house is near the sea, and in winter he falls asleep to the sound of humpback blows as they surface to breathe. This picture was taken on a mid-December afternoon, the darkest time of the year. He had located the feeding group by listening for their blows and watching for their pale tail flukes. To illuminate the scene against the mountain backdrop, Audun had designed a system involving a powerful torch attached to the camera as well as flashes. Here one giant dives, exposing the unique 'fingerprint' pattern on its flukes. The great blows of two other whales are also illuminated as they surface just behind.

Canon EOS-1D X + Tamron 70-200mm f2.8 lens at 70mm; 1/250 sec at f3.5; ISO 2000; x2 Canon 600 flashes; 3200 lumen LED torch.

Sea eagle snatch

When young, Audun spent many years helping to ring white-tailed sea eagles along the coast of northern Norway, developing a passion for them and buying his first camera at the age of 12 just to photograph the eagles. Watching them snatch fish from the surface of the sea, he started to fantasize about what the deadly business might look like from below. The set-up took several years to perfect and involved many weeks of frustration, but Audun eventually managed to photograph the millisecond moment he had envisaged, with water cascading off the fish as it was grabbed from above. The shot depended a lot on the tide, wind direction and light and involved gradually getting the eagle used to his boat and the partially visible submerged camera. This was anchored on a long line to the sea floor and linked to a remote control, with a dead fish as bait. The eagle – a 27-year-old female – is ringed and could well be one of those whose eyes he gazed into all those years ago.

Canon EOS 5D Mark III + 8-15mm f4 lens at 15mm; 1/2500 sec at f8; ISO 2000; underwater housing + specially designed remote control.

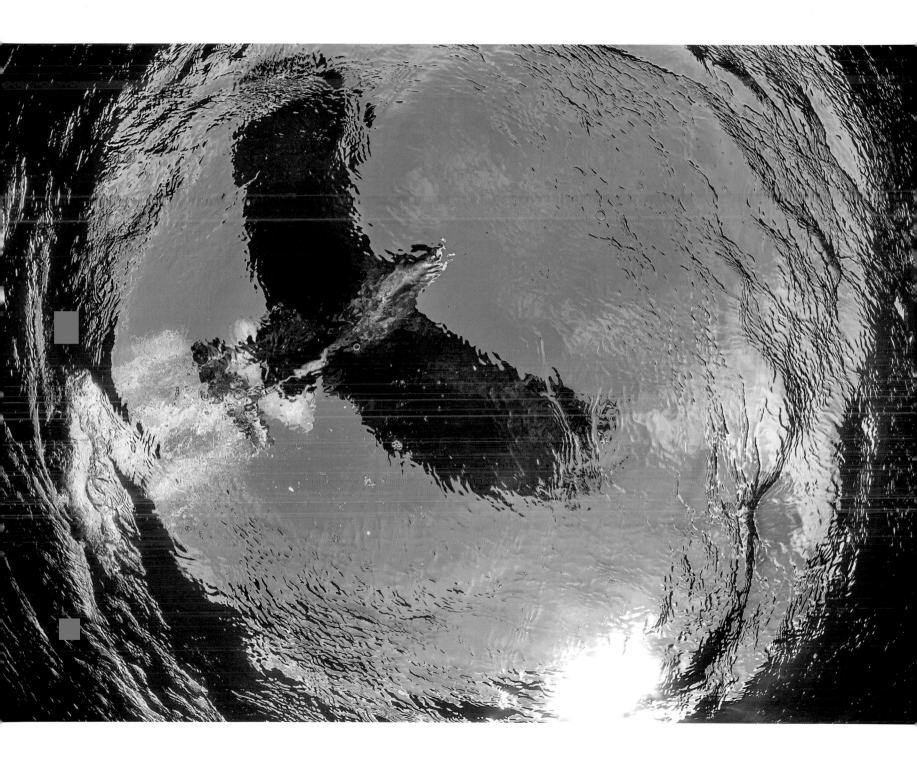

Plants

The heart of the swamp
Georg Popp
AUSTRIA

The morning sun filters through mist and the thick drapes of Spanish moss that festoon a dense stand of 1,000-year-old bald cypress trees in Louisiana's Atchafalaya Basin. It's one of the last remaining old-growth cypress stands in the USA, representative of how the swamps of the 'deep south' used to look. Where the buttresses emerge from the surface, they are 2–5 metres (7–16 feet) in diameter and wider still below water. The only way to reach the heart of the forest is by kayak – a two-hour trip. The water is too deep and dangerous to wade through, but near a tree buttress it's possible to stand in hip-high waders and rest a tripod on one of the many aerial roots. Having located in daylight the ideal spot for an image, Georg pinpointed it with a GPS device and then, using a head torch, paddled into the swamp in the dark and waited for dawn. His aim was to recreate the mystical, eerie atmosphere in the heart of the ancient swamp forest, something few have experienced. As dawn broke, the cypress stand came alive with the sounds and movements of an abundance of creatures – alligators, turtles, amphibians and countless birds, including bald eagles and osprey – 'a magical experience,' says Georg. Bald cypress evolved to live with naturally fluctuating water levels. Today, though, levees and dams keep the water at a constant level in this part of the basin. The soil never drains, and so the cypress seeds can no longer germinate.

Nikon D810 + 70-200mm f2.8 lens at 170mm; 1/320 sec at f8; ISO 200; Gitzo tripod.

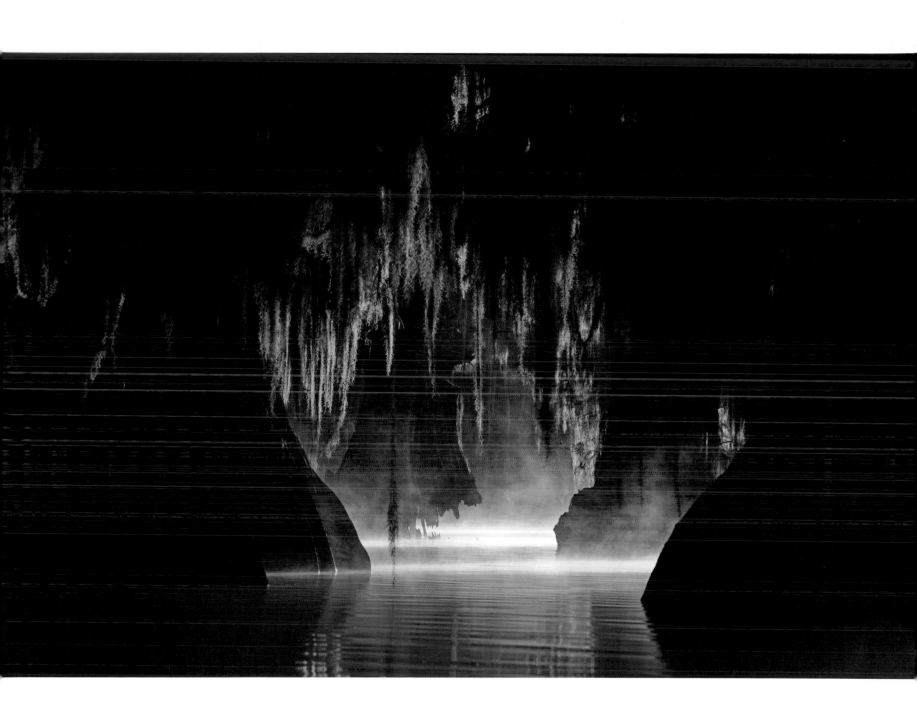

Meadow canvas
Klaus Tamm
GERMANY

On his way home one evening, Klaus spotted some impressive lizard orchids beside the road near Greve in Tuscany, Italy. With insufficient light to take the pictures he wanted, he decided to come back the next day. But when he did, he found the site devastated: wild boars had dug up and eaten the orchid tubers overnight. Then Klaus caught sight of two solitary, pink blooms in the meadow on the opposite side of the road. Standing tall and straight, with their sword-shaped leaves and spikes of pink flowers, these Italian gladioli stood out against a sea of tufted vetch and other meadow species. 'The scene was so tranquil,' recalls Klaus, 'disturbed only by the wonderful buzz of insects.' The species is found throughout Italy, but probably originated from the Middle East (it is native to much of Eurasia and North Africa). Adopting a low angle and a wide aperture, Klaus isolated the blooms against the colourful canvas of vetch to create an artistic image that he hoped would make people pause and reflect.

Canon EOS-1D X + 100mm f2.8 lens; 1/800 sec at f2.8 (+1 e/v); ISO 100.

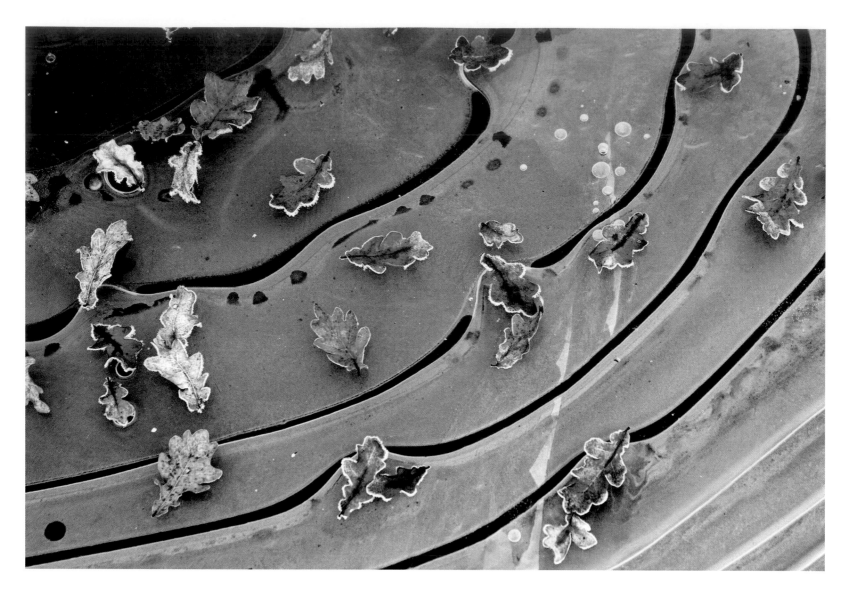

Frozen moments
Hadrien Lalagüe
FRANCE

Hadrien was following a woodland trail he had known since childhood when he came across a phenomenon that he had never seen before. An unusual pattern of 'freeze and thaw' ice overlaid a small ditch. Intrigued by the patterns and the scattering of frosted oak leaves, Hadrien stopped to photograph it. 'I spent some time looking for where the ice rings were most interesting,' he explains. 'Then I stood directly over the ditch, trying not to slip in.' Filling the frame, he composed the shot with the deepest water top left, grading to shallow water at the ditch edge. The simple image has particular meaning for Hadrien, reminding him of the woodland of his childhood.

Canon EOS 20D + Tamron 28-75mm f2.8 lens at 57mm; 1/40 sec at f5; ISO 200.

Pine pioneer
Heike Odermatt
THE NETHERLANDS

In July 2010, after weeks of hot, dry weather, a wildfire broke out in heathland in North Brabant, the Netherlands. It took more than a week to extinguish and destroyed 200 hectares (500 acres) of forest and heath. When Heike visited two years later, she wanted to record how nature was recovering. Lowland heath, a threatened habitat and home to many specialized plants and animals, needs grazing or careful controlled burning to prevent its succession to scrub and woodland. 'I went in search of the new life and colour I knew I would find among this beautiful tangle of dead heather.' What she found was this young pine seedling emerging from the shelter of the silver-grey weave. Heike framed her shot without a tripod to avoid interfering with the plants, creating an image symbolizing the hope of new life and the resilience of nature.

Canon EOS 5D Mark II + 24-105mm f4 lens at 32mm; 1/60 sec at f14; ISO 200.

Birds

The company of three
Amir Ben-Dov
ISRAEL

Red-footed falcons are social birds, migrating in large flocks from central and eastern Europe to southern and southwestern Africa. The closest relationships seem to be pairs or parents with first-year chicks, but otherwise, they maintain a degree of personal space. But these three red-footed falcons were different. Amir spent six days watching them on agricultural land near Beit Shemesh, Israel, where their flock was resting on autumn migration, refuelling on insects. What fascinated him was the fact that two subadult females and the full-grown, slate-grey male were spending most of their time together, the two females often in close physical contact, preening and touching each other. They would also hunt together from a post rather than using the more normal hovering technique. As so often happens in photography, it was on the last day in the last hour before he had to return home when the magic happened. The sun came out, the three birds perched together, and a subtle interaction took place: one female nudged the male with her talon as she flew up to make space on the branch for the other female. Exactly what the relationship was between the three birds remains a mystery.

Canon EOS-1D X + 500mm f4 lens; 1/1600 sec at f8 (+0.33 e/v); ISO 500.

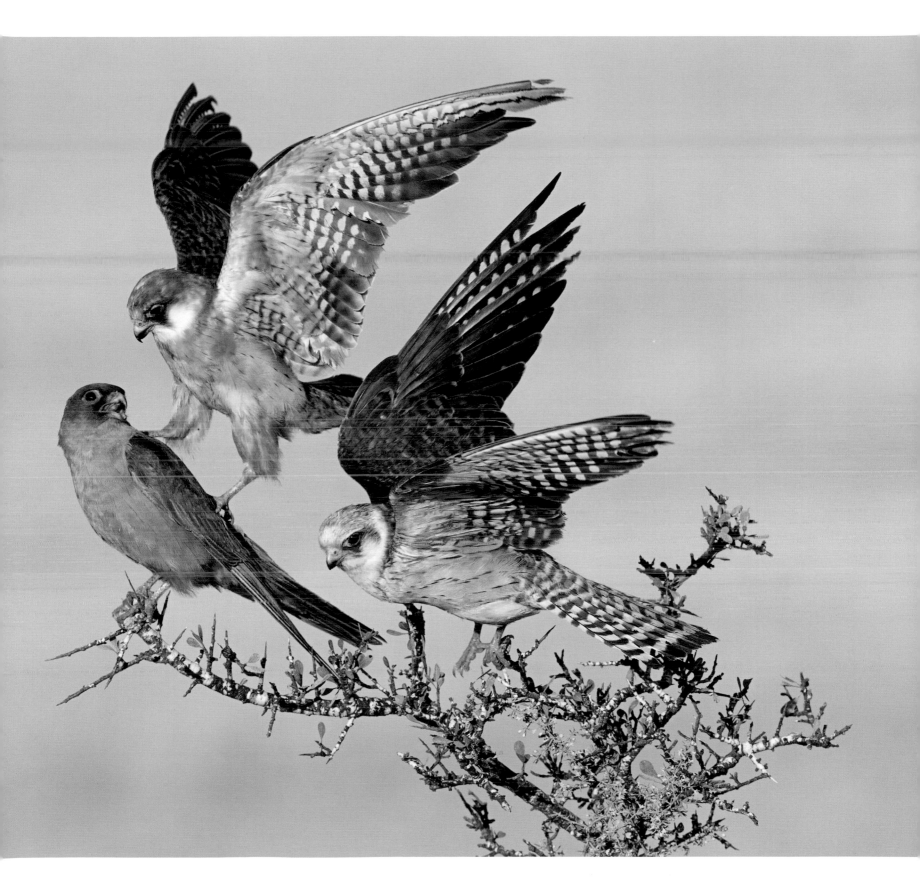

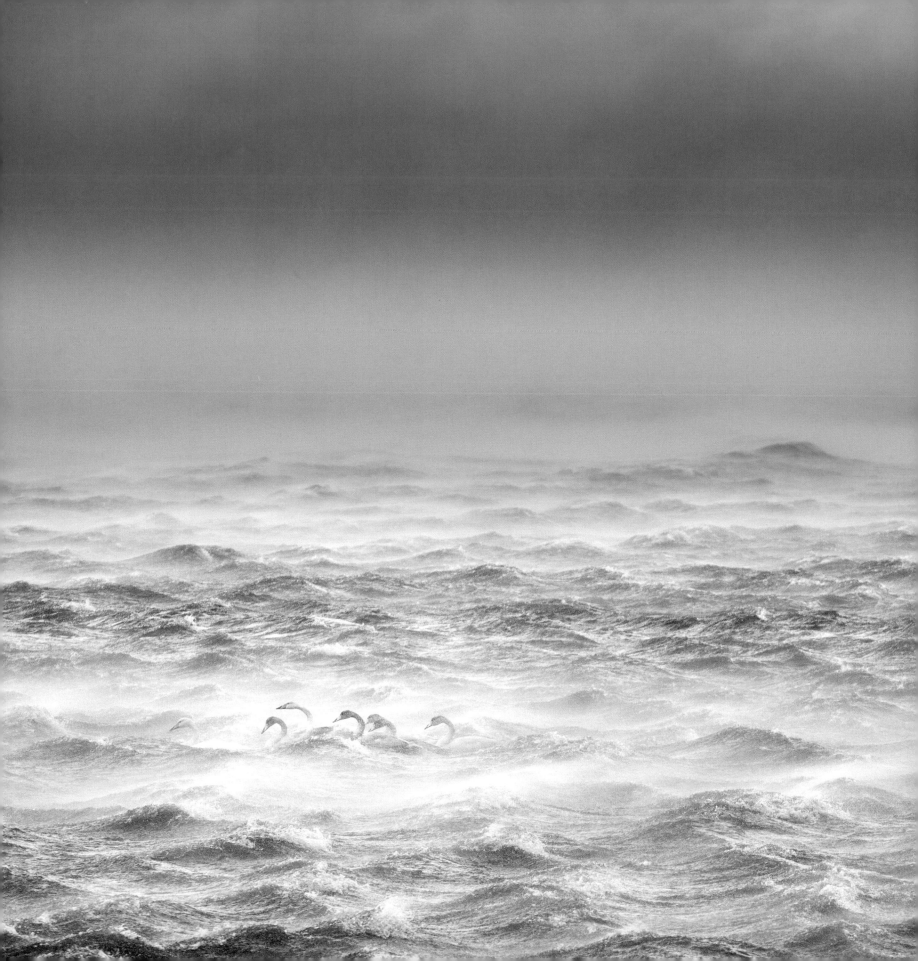

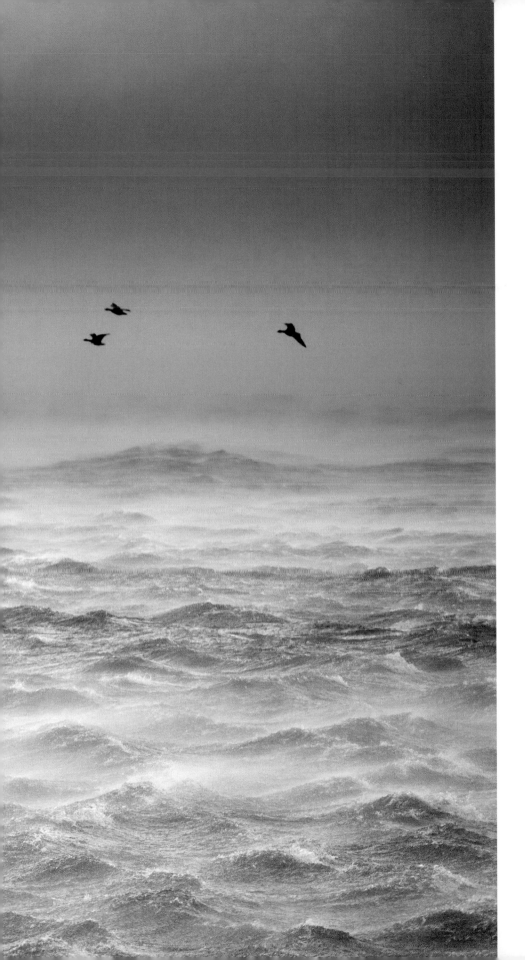

Battling the storm
Vincenzo Mazza

ITALY

Earlier in the day, a violent January storm had closed Iceland's south-coast road between Vik and Reykjavik, and though it had reopened, the wind was still very strong. Driving back to Reykjavik, Vincenzo passed a lagoon being whipped by fierce gusts. The air was filled with spray, and as the light from the setting sun tinted it a surreal colour, he drew up, intending to snatch a shot. 'As soon as I opened the car door,' he says, 'the wind took it, bending it right back on its hinges.' After a moment of shock, his attention was drawn to the surprising sight of a family of whooper swans in the water battling the wind and waves – surprising because, in January, Iceland's whoopers would normally be in Britain or Ireland, where they migrate to escape the Icelandic winter. 'The wind made it impossible to stand still, let alone frame a composition,' says Vincenzo. But then, in the momentary lull between powerful gusts, three Icelandic greylag geese – also normally winter migrants to Britain and Ireland – blew into the frame, providing the balancing touch to his shot.

Canon EOS 5D Mark III + 70-200mm f4 lens at 163mm; 1/800 sec at f5.6; ISO 500.

Great egret awakening
Zsolt Kudich

HUNGARY

When the River Danube flooded into Hungary's Gemenc Forest, more than a thousand great egrets flocked to the lake to feed on the stranded amphibians, fish and invertebrates. Working on a project to document the last untouched regions of the Danube, including the floodplains, Zsolt was delighted to find a sixth of Hungary's great egret population in the one place. By 1921, hunting had reduced their number to just 31 pairs. Today, habitat loss is the big threat. Using the soft dawn light, Zsolt wanted to convey the impression of a multitude of birds. So he pitched his camouflaged tent nearby, sleeping just a few hours a night for five nights. His chance came when a fishing white-tailed eagle sent some of the egrets into the air. With a slow shutter speed to blur the wings and a large depth of field to keep in focus those standing, Zsolt got his memorable image.

Nikon D300 + 70-200mm f2.8 lens at 125mm; 0.4 sec at f11; ISO 1000; Gitzo tripod.

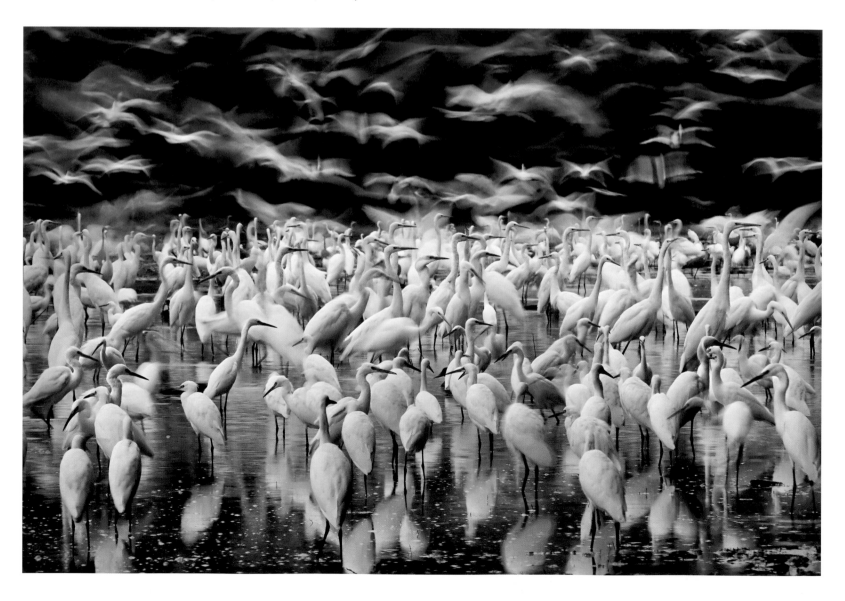

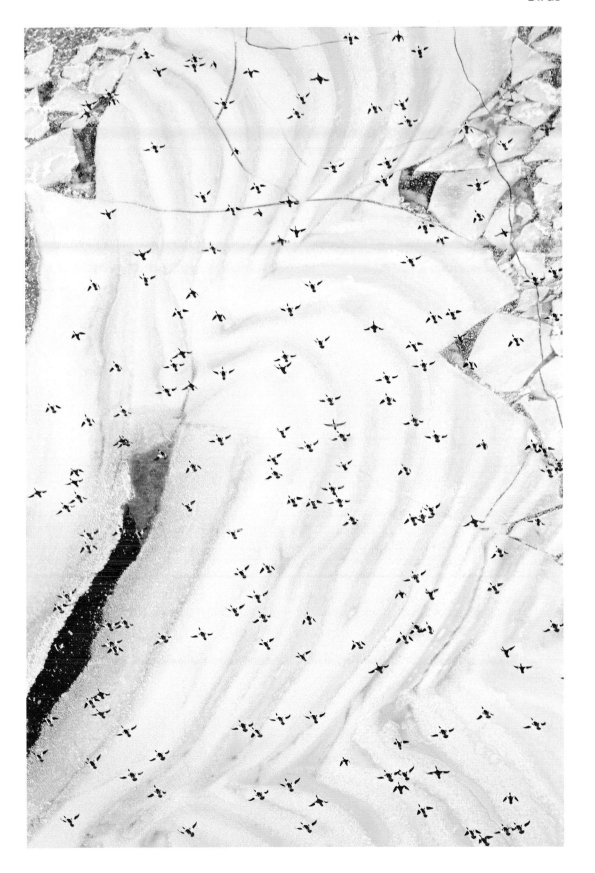

Ice flight
David Stimac
USA

When David was invited to accompany biologists on aerial waterfowl surveys over Lake Erie, he didn't hesitate. 'Waterfowl are my main inspiration,' he explains, 'and the incredibly cold winter had produced a lot of ice, which I knew would provide some interesting images.' Lake Erie is the shallowest of the five Great Lakes in North America, making it the warmest in summer and the first to freeze in winter (in the past the ice has been thick enough to drive across). As they flew over one of the few remaining stretches of open water, created by the warm outflow of a power plant, they passed a large flock of common mergansers. Easily identified by their white wing patches, these are the largest of the sawbills (diving ducks with long, serrated bills for catching fish), with a wingspan of up to a metre (3 feet). They are widespread across the northern hemisphere, overwintering on freshwater lakes and rivers. From his cramped backseat position, David constantly cleaned the frost from the window, the temperature being no more than −14°C (6°F), and set a fast shutter speed to combat the plane's motion. The layer of mergansers added intricacy and movement to the patterns in the ice.

Nikon D300 + 70-200mm f4 lens at 200mm; 1/2500 sec at f5 (+0.7 e/v); ISO 800.

Inside job
Charlie Hamilton James
UK

Of thousands of images taken over three weeks with
a specially adapted camera positioned inside many
different zebra and wildebeest carcasses, 'this was the
only shot that worked,' says Charlie. On assignment for
National Geographic in Tanzania's Serengeti National
Park to document the severe decline in Africa's vultures,
he wanted to capture the scavengers' feeding scrum
from its very centre. 'Vultures are incredibly wary of
anything out of the ordinary,' explains Charlie, 'which
is why it took so long.' This zebra carcass, the remains
of a lion kill, had attracted a mixed crowd – Rüppell's
griffon vultures (centre frame) dominated the feast,
while the smaller white-backed vultures (with black bills)
waited their turn close by. Both species, once abundant
and widespread, are now endangered, suffering rapid
declines as a result mainly of poisoning, particularly
from the pesticide Carbofuran, but also because of
habitat loss to agriculture and pastoralism, fewer wild
ungulates (less carrion), hunting and persecution.
As they squabbled, stretching out their strong, bare
necks to gorge on carrion and bone fragments,
Charlie's perseverance paid off. The low angle captured
the action of a clawed foot and open bill, while the
onlooker's profile and the marabou stork (far right) in
the distance completed the composition for Charlie.

Panasonic Lumix DMC-GX7 + 7-14mm f4 lens at 7mm;
1/500 sec at f5.6; ISO 800; PocketWizard remote release.

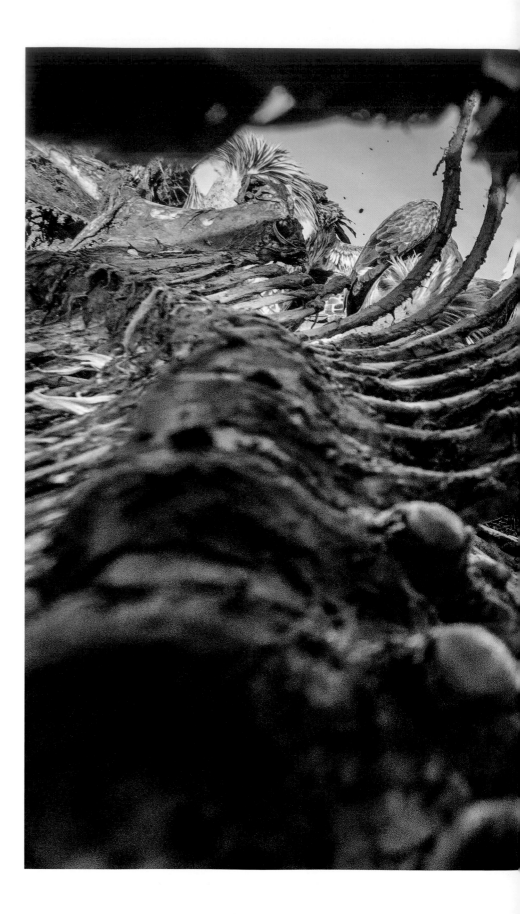

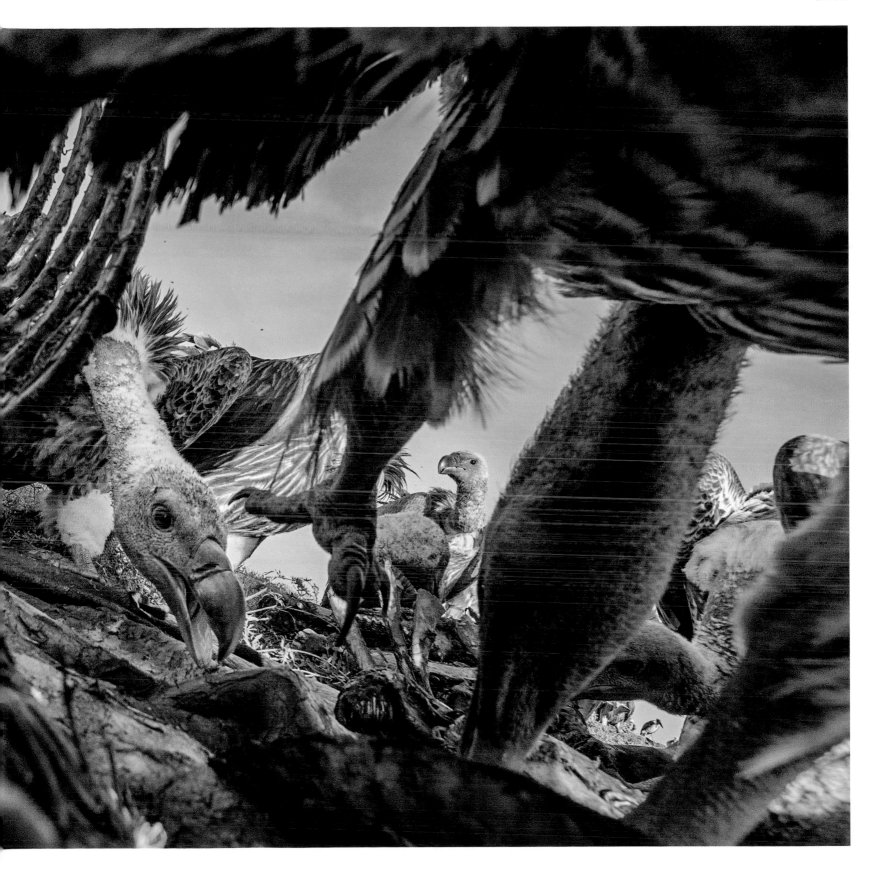

Amphibians and Reptiles

Still life
Edwin Giesbers
THE NETHERLANDS

A great crested newt hangs motionless near the surface of the stream. Also motionless in the water, in Gelderland in the Netherlands, was Edwin in a wetsuit. He had very slowly moved his compact camera right under the newt, and though he knew the shot he wanted, he had to guess at the framing and literally point and shoot. The male had just taken a breath and was possibly warming up at the surface. It was a cold April morning, and the trees were not yet in leaf, but it was mating time for these large newts, and the males were already on the lookout for females. Edwin took this shot as part of a major story on the threat facing amphibians throughout the Netherlands and Belgium: an Asian skin fungus similar to the one that has annihilated frogs and toads worldwide and has all but wiped out fire salamanders in the Netherlands. Scientists are bracing themselves for a collapse of European amphibian populations, unless some way is found to stop the fungus from spreading.

Canon G15 + 28-140mm f1.8-2.8 lens at 28mm; 1/500 sec at f6.3; ISO 200; Canon housing.

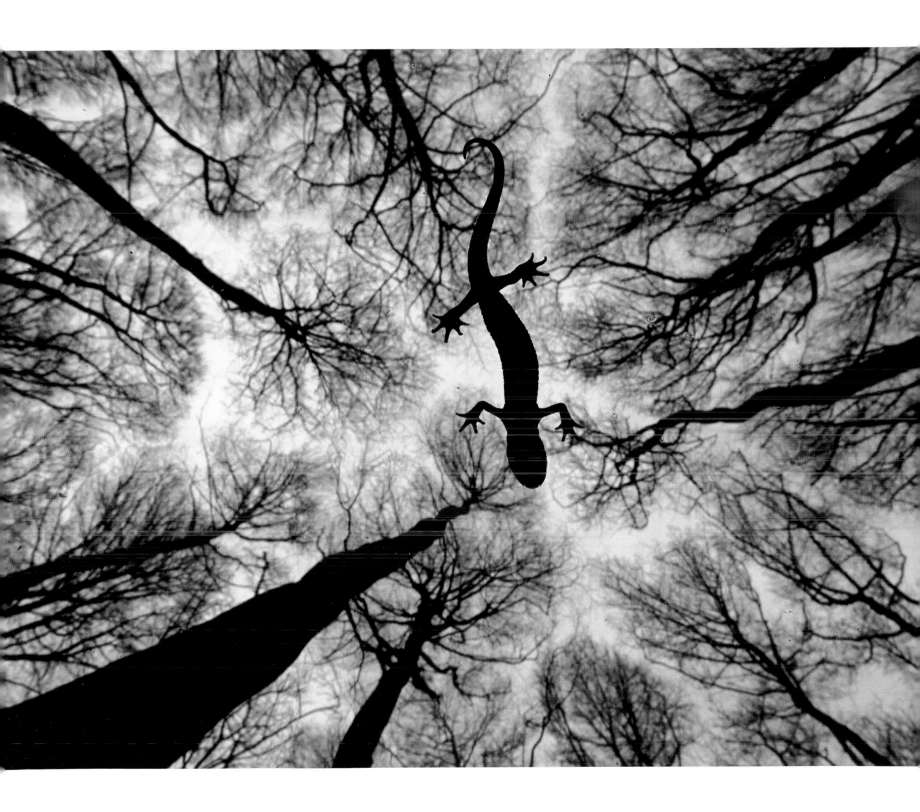

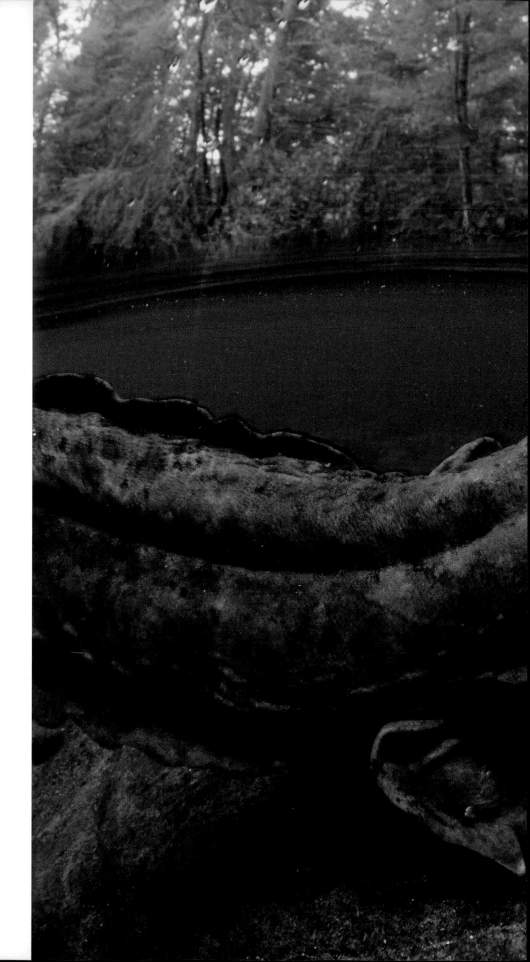

Head-strong hellbenders
David Herasimtschuk
USA

It took three years before David managed to photograph a fight between male hellbenders, spending hours in the water watching and, mostly, waiting. Fights break out at the end of summer, when males compete over the best nest sites – cavities under large, flat rocks are favourites – into which they can entice females to lay their eggs. The males then guard the eggs and the resulting larvae. These huge, long-lived North American salamanders, up to 75 centimetres (29 inches) long, will fight over breeding territories, and dominant males will guard the entrances to the nest holes. To photograph their breeding activities, David first had to find his hellbenders – a challenge, as they have declined significantly, mostly due to degradation of rivers where they live but also because of humans moving rocks and destroying ancient nest sites or even, accidentally, the animals themselves. Working closely with biologists in North Carolina, he gained access to a known breeding location. For the first two years, heavy rain brought deep, turbid water, and he was forced to give up, but in the third season, he got lucky. Here, two large males have clamped on to each other's jaws and, says David, 'are twisting and turning as the flow pushes them down river'. The fight lasted more than 10 minutes, until the smaller male gave up the struggle. Using a split-level shot to show their environment, David captured an image, probably the first ever, of a head-to-head battle between these icons of crystal-clear, healthy rivers and streams.

Canon 5D Mark III + Sigma 15mm f2.8 lens; 1 sec at f22; ISO 1250; Aquatica housing + dome; x2 Inon Z-240 strobes.

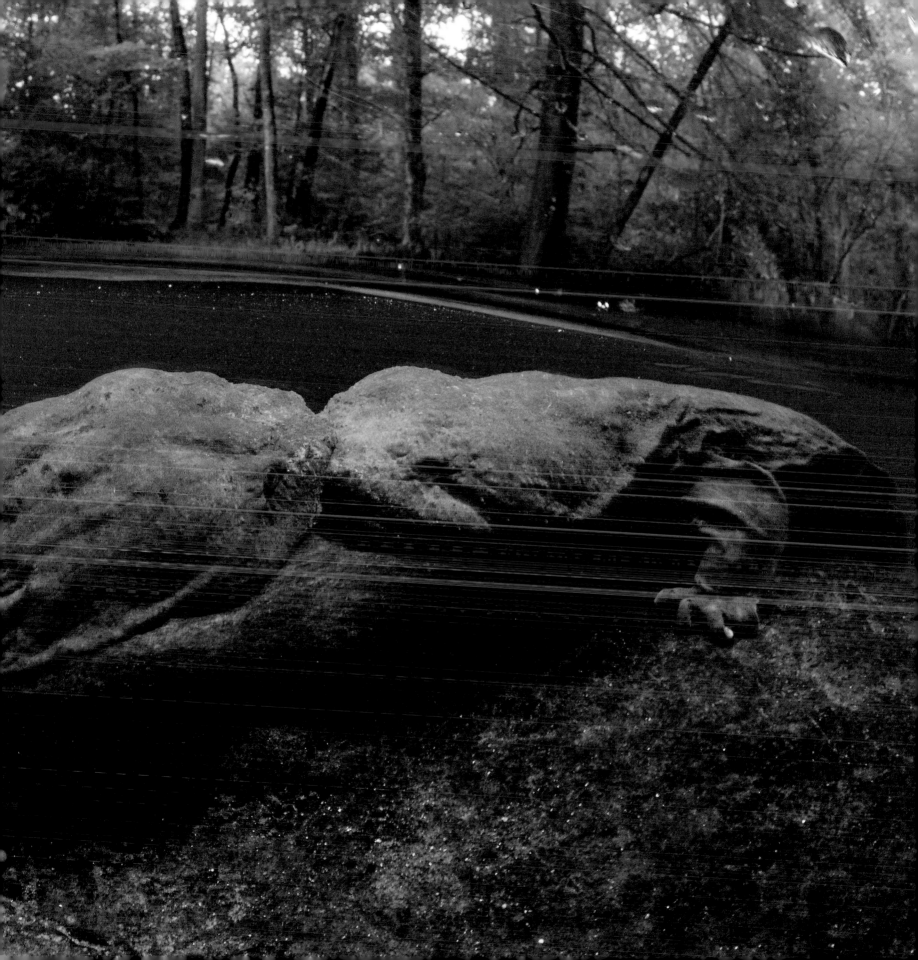

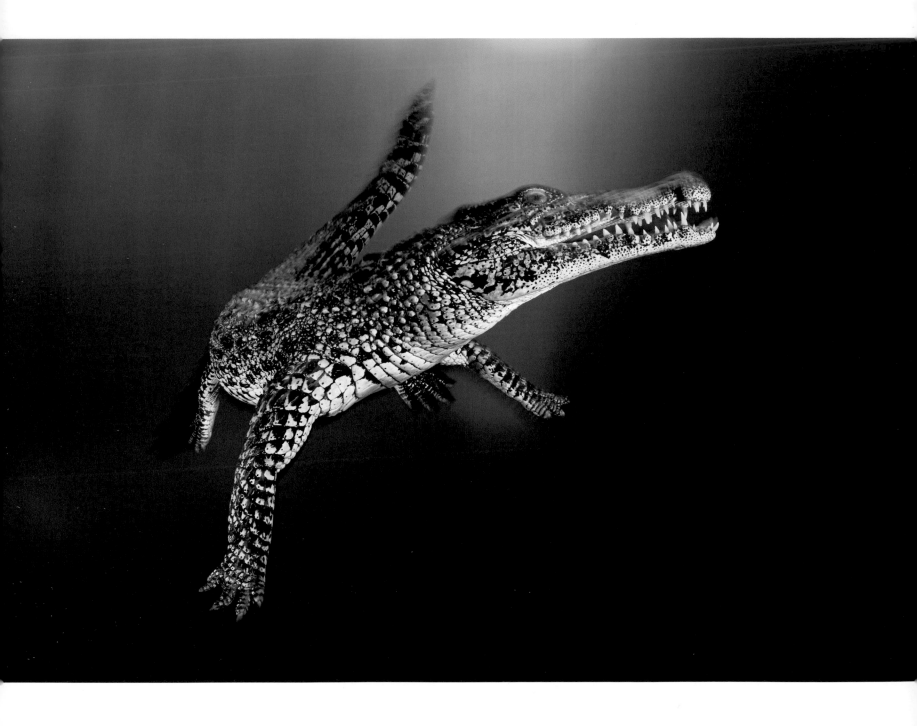

Cuban survivor
Mirko Zanni
SWITZERLAND

It was Mirko's ambition to photograph the critically endangered Cuban crocodile. Threatened mainly by hunting for meat, much of it for the tourist trade, and hybridization with native American crocodiles, it has one of the smallest natural distributions of any living crocodilian. It's thought that 3,000–6,000 remain, in the Zapata Swamp in western Cuba and in the Lanier Swamp on the nearby Isle of Youth. Sometimes known as the pearly crocodile after the yellow dotted pattern on its back, this medium-sized but aggressive species is particularly agile on land, with strong hind legs and short toes that lack webbing. Enlisting the help of local biologists to find his subject and porters to carry diving and camera equipment, Mirko set off to look for crocodiles in and around the cenotes (limestone sinkholes) of the Zapata Peninsula. This was the most special image. 'I spent hours in the water with this one,' he says. At one point, 'it sank down right in front of me, very close.' He followed it down through the clear cenote water and, before it resurfaced to breathe, made this rare picture of a Cuban crocodile.

Canon EOS 5D Mark II + 15mm f2.8 lens; 0.4 sec at f22; ISO 100; Seacam housing; two Sea & Sea YS-250 strobes.

Komodo judo

Andrey Gudkov

RUSSIA

The fight was fast and unexpected. Andrey had been to Indonesia's Komodo National Park many times before, hoping to witness a battle between male Komodo dragons – the largest lizards in the world, up to 2.5 metres (8 feet) long. And though he had visited in August, when males are most likely to battle over females, he had never been lucky. But on this December morning, on Rinca Island, he had found two large males hissing angrily at each other. To his surprise, the confrontation escalated. The lizards reared up on their hind legs, supported by their long, muscular tails, and suddenly everything came together: two formidable dragons 'dancing the tango' at the crest of a hill against a beautiful backdrop, without the usual tall grass obscuring the action. Andrey seized his chance, knowing that Komodo dragons can move fast and that their bites are venomous, secreting a mix of toxic substances from glands in their jaws into the wounds made by their teeth. The dragons fought two consecutive bouts of a few seconds each until one overpowered the other, knocking him over backwards, and the pair walked off in different directions. With quick reactions and a fast shutter speed, Andrey had nailed the shot he had dreamt of.

Canon EOS-1D X + 100-400mm f4.5-5.6 lens at 100mm; 1/2000 sec at f7.1; ISO 800.

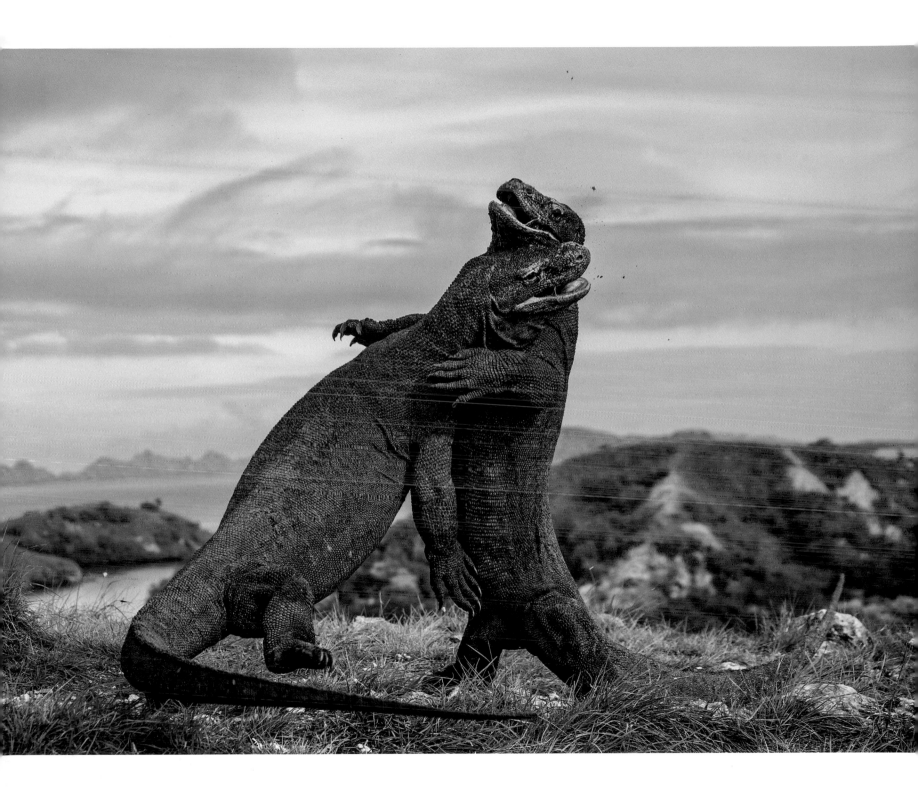

Turtle flight
David Doubilet
USA

A hawksbill turtle soars through the crystal waters of Kimbe Bay, Papua New Guinea, a cornerstone of the Coral Triangle that David knows well – one of the most diverse and coral-rich marine areas on the planet. His intent, in more than five decades as an underwater photographer, is 'to connect people with the incredible beauty of the oceans and their silent devastation'. The critically endangered hawksbill turtle – named after its hooked beak, used to dig out invertebrate prey, mainly sponges – has been exploited for thousands of years as the sole source of commercial tortoiseshell, prized for jewellery and ornaments. Thought to have declined by 80 per cent over the past century, the species is threatened by the illegal trade in its shell and demand for its eggs, meat and juveniles, stuffed as exotic gifts. It also faces the loss of beach nesting sites, entanglement in fishing lines, the deterioration of the coral reefs where it feeds and climate change (particularly as the gender of hatchlings is determined by incubation temperature). David angled his camera to set the turtle's amber underside against the blue water, gently lit it with a separate strobe, framed it against a backdrop of torpedo-shaped barracuda and batfish (left) and, using a slow shutter speed, caught the essence of a hawksbill gliding through its realm.

Nikon D3 + 17-35mm f2.8 lens at 17mm; 1/13 sec at f22; ISO 320; Seacam housing; Sea & Sea YS-250 strobes.

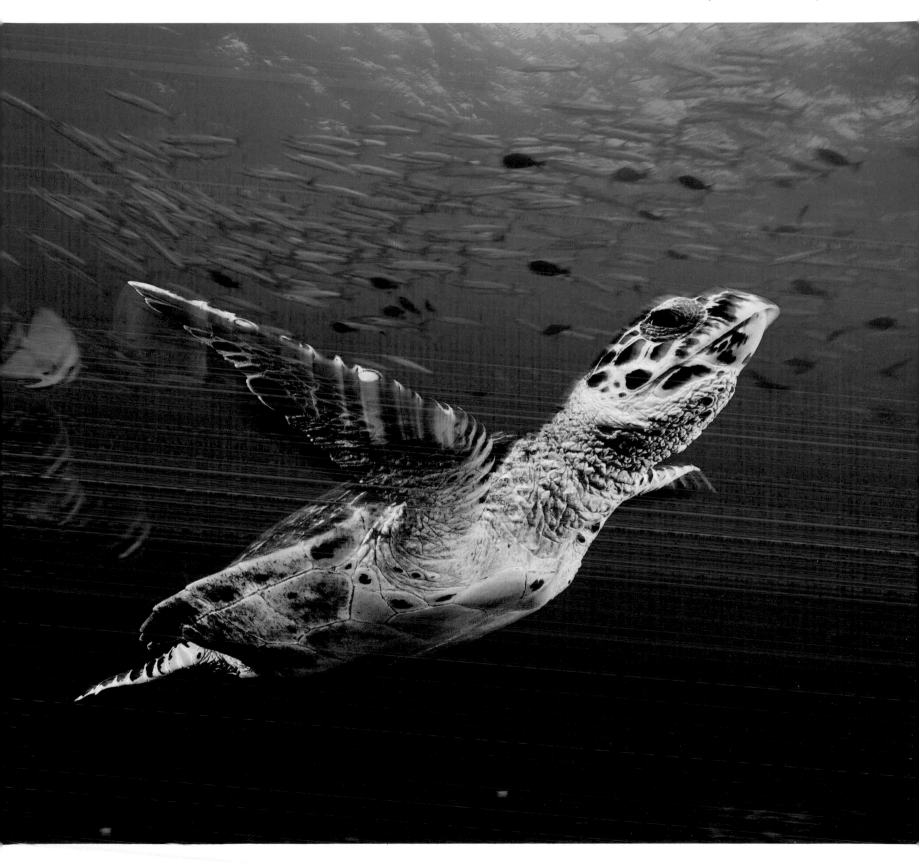

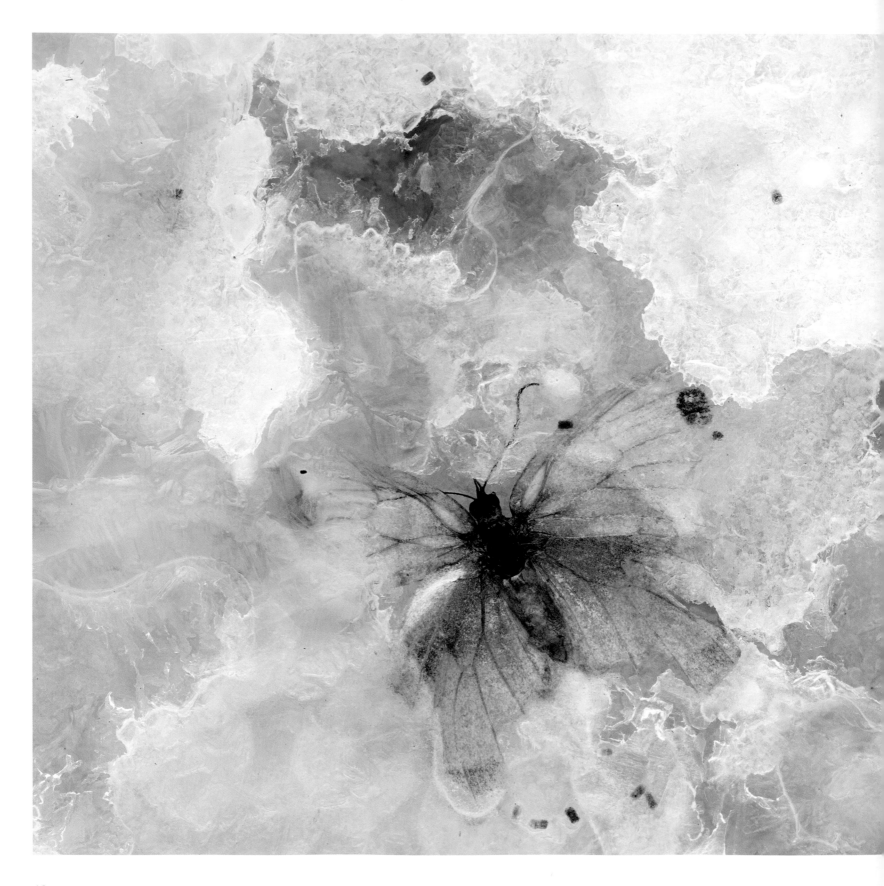

Invertebrates

WINNER

Butterfly in crystal

Ugo Mellone

ITALY

In the rocky crevices along the coast of Salento, layers of salt build up as seawater spray from storms evaporates under the strong summer sun. Ugo grew up in this region of Italy and takes many landscape images along the last stretch of the coast that remains wild and pristine. But he also keeps watch for the little details that tell stories and the miniature landscapes to be found among the rocks and in the limestone cliffs. He always finds something to inspire him. On this exploration, what caught his eye was the splash of orange in a solid salt pool. It was a female southern gatekeeper that had become mummified by the saltwater and entombed in a coffin of salt crystals. Most of her wing scales had gone, perhaps as she fluttered to try to escape, but her characteristic eyespots were still visible.

Canon EOS 7D + 100mm f2.8 lens; 1/10 sec at f11; ISO 100.

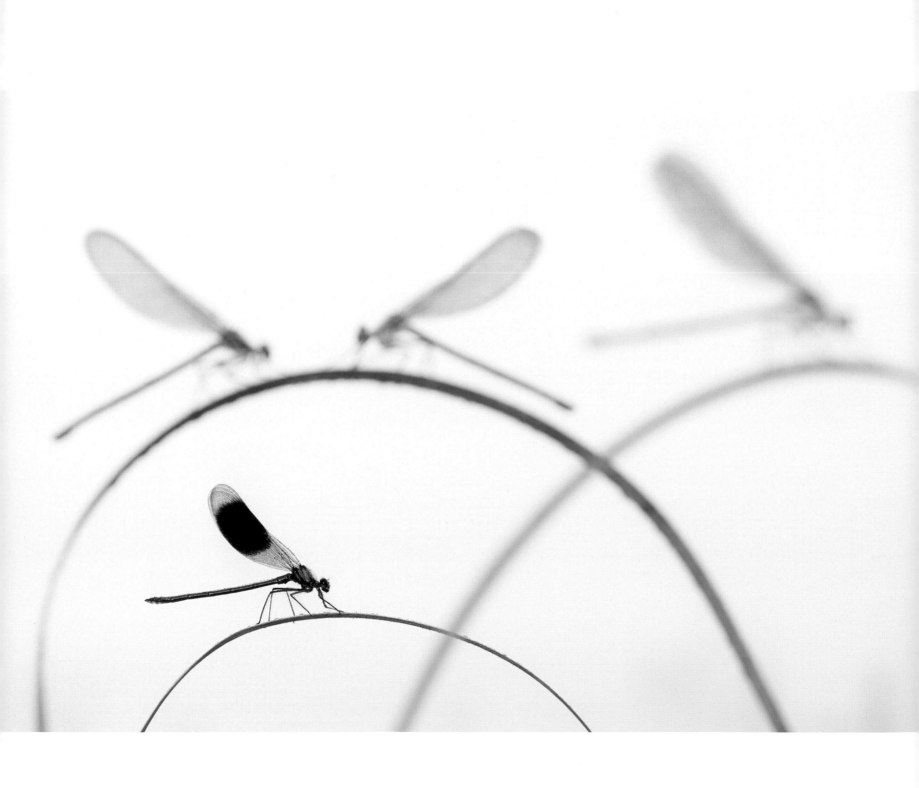

Waiting for the sun
Edwin Giesbers

THE NETHERLANDS

Still drowsy, banded demoiselles wait for the sun to rise and warm their bodies so they have enough energy to fly and carry on with defending their territories, courting, mating and laying eggs. Edwin had discovered where a group of damselflies were roosting, in dense vegetation on the bank of a stream near his home in the Netherlands, and he arrived before dawn to be there when they woke and emerged onto leaves to await the sun. It takes them a couple of hours to absorb enough energy, and so it was easy for Edwin to get close. He focused past the three females nearest him and on the male, using a gentle flash to pick out the hint of his colours. If the sun doesn't warm the demoiselles, they may not be able to feed, and should the weather stay bad for a few days they might drop off their perches or be picked off by birds. Edwin spent a couple of weeks watching and photographing them. When they were ready to fly, the males would depart to guard their territories, where they would try to attract females with a butterfly-like courtship flight. Only when a female is convinced that this energy-consuming flight is good enough will she mate.

Nikon D7100 + Tamron f2.8 90mm; 1/250 sec at f9 (+2 e/v); ISO 400; built-in flash.

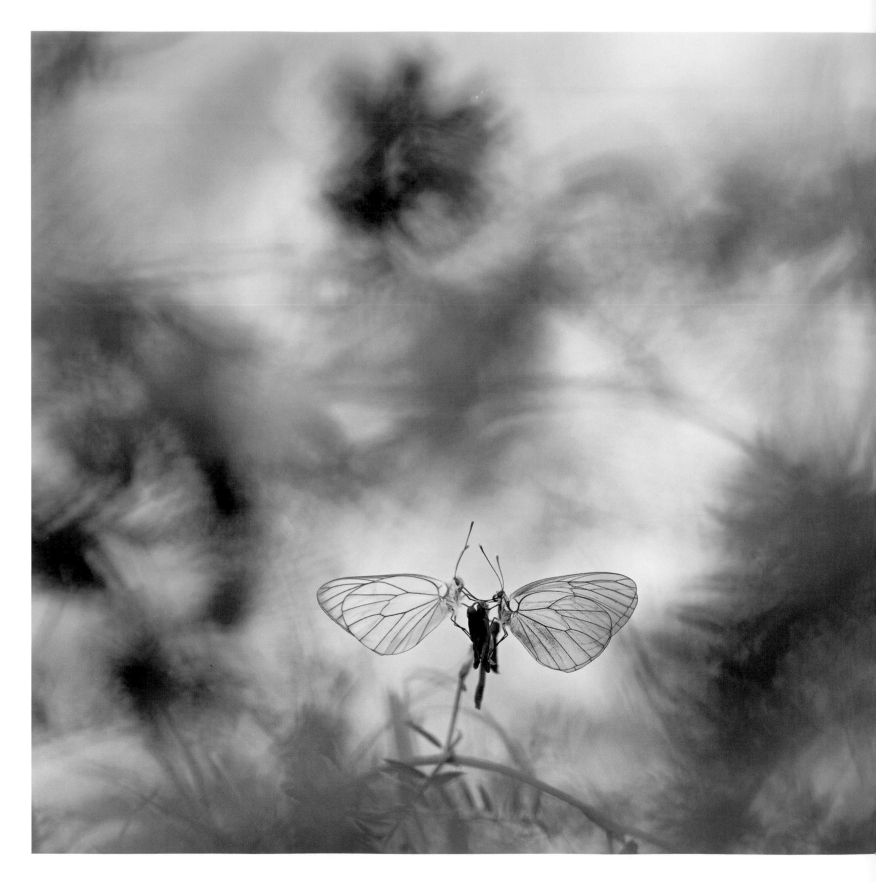

Wings of summer
Klaus Tamm
GERMANY

On an evening walk in Tuscany, Italy, Klaus discovered a meadow that was not only a riot of summer colour but also alive with butterflies. What focused his attention was a pair of black-veined white butterflies perched opposite each other on a vetch flower. The female (right) was distinguished by the brown tinge to the upper edge of her forewings and a slightly more transparent look, the result of losing scales, possibly while repelling the unwanted attention of males. But the light was fading, and so Klaus decided to return first thing the next morning, knowing that the butterflies were almost certainly roosting in the meadow, as black-veined whites tend to gather in the same areas and roost communally. At sunrise, he found the butterflies in exactly the same spot, warming up. To highlight the delicacy of the pair, balanced on either side of the flower, he used a wide aperture to blur the blend of meadow colours and then framed the butterflies against a window of sky.

Nikon D7100 + 200-400mm f4 lens + 1.4x extender at 550mm; 1/1250 sec at f5.6; ISO 500.

Beetle beauty and the spiral of love
Javier Aznar González de Rueda

SPAIN

Javier was on the lookout for reptiles and amphibians on the slopes of Ecuador's active Tungurahua volcano when he came across these mating jewel weevils, just a few millimetres long, the likes of which he had never seen before. Weevils may mate for several hours, the male guarding the female against rivals, and this provided Javier with the time he needed to take the shot. The depth of field (the amount in focus) was very narrow, and so as the pair moved along the tendril, Javier had to recompose the shot repeatedly to keep them in focus. Once mated, the female uses her long rostrum to bore a hole into the plant in which she lays her eggs, so the larvae hatch protected within the plant's tissues, surrounded by food. The beetles' eye-catching metallic colours, caused by reflected light from the structural arrangements of the many layers of chitin that form their hard exoskeletons, probably disguise them as water droplets, so they blend in with their humid forest habitat. To soften the reflections, Javier had to use two large diffusers. His patient work captured their exquisite colours and tiny forms as they mated, perched on their spiral support.

Canon EOS 70D + Sigma 180mm f3.5 lens; 1 sec at f16; ISO 100; x2 Yongnuo flashes; cable shutter release; Manfrotto tripod + ballhead.

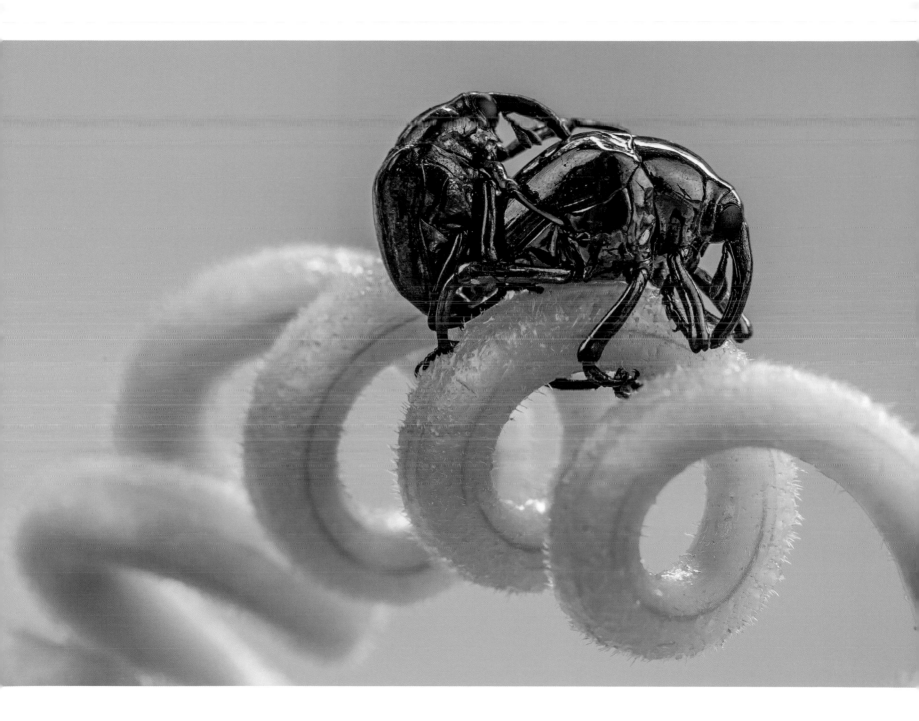

Mammals

A tale of two foxes
Don Gutoski
CANADA

It's a frozen moment revealing a surprising behaviour, witnessed in Wapusk National Park, on Hudson Bay, Canada, in early winter. Red foxes don't actively hunt Arctic foxes, but where the ranges of two predators overlap, there can be conflict. In this case, it led to a deadly attack. Though the light was poor, the snow-covered tundra provided the backdrop for the moment that the red fox paused with the smaller fox in its mouth in a grim pose.

Canon EOS-1D X + 200-400mm f4 lens + 1.4x extender at 784mm; 1/1000 sec at f8; ISO 640.

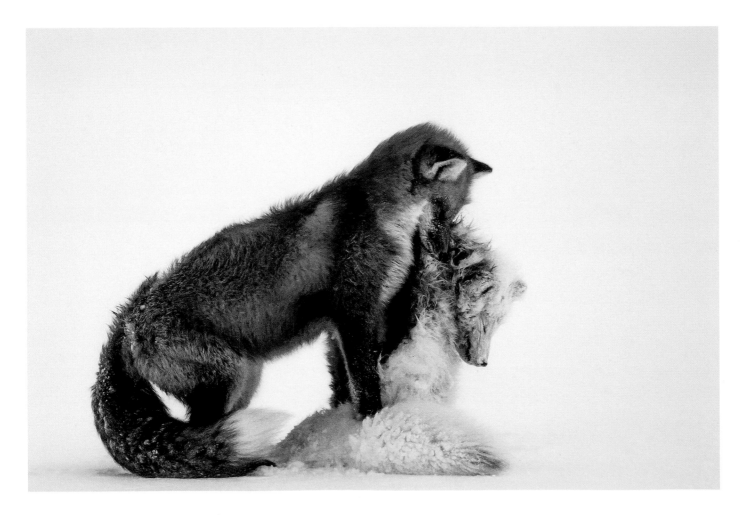

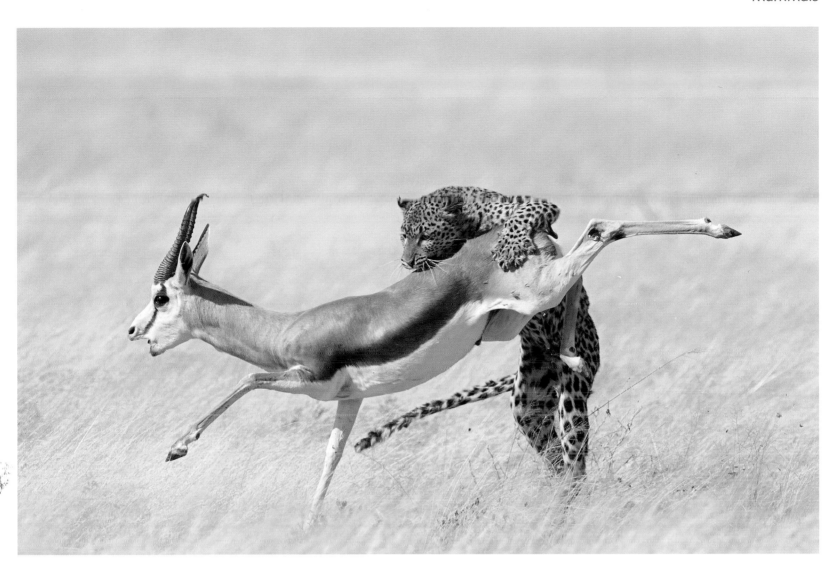

The final leap

Wim van den Heever

SOUTH AFRICA

Wim knew that if he continued to follow this leopard for another few days, he might witness something special. She was hunting out on the plains of Namibia's Etosha National Park, where the lack of vegetation meant that a normal leopard-style ambush wasn't possible. 'I was amazed to see her trying to stalk in such short grass,' says Wim. The first hunt he witnessed failed when the wind changed direction and her scent gave her away. But shortly after, a large male springbok started moving in her direction. As he approached, 'she just disappeared into the short grass,' says Wim. 'Then to my amazement, she launched herself at the ram with incredible agility and strength.' Wim reacted instantly, and captured the action through the window of his vehicle as the leopard gripped the springbok with her powerful shoulders and pulled him down.

Nikon D4 + 600mm f4 lens; 1/3200 sec at f8; ISO 1000; Badger Door Bracket + Wimberley Gimbal head.

The scales of fortune
Tristan Dicks

SOUTH AFRICA

Forget the Big Five. The holy grail for a safari guide in South Africa's Sabi Sands region is a small, nocturnal, armour-plated mammal – Temminck's ground pangolin. Though legally protected, pangolins are in severe decline, exploited as bushmeat and in traditional medicine, where their scales (fused hair) are among the coveted body parts. Leading a safari one evening in Lion Sands Game Reserve, Tristan was thrilled to come across the rare sight of a ground pangolin on the track. A pangolin will normally react to a human by freezing or curling up into a tight ball, but this one seemed very relaxed. 'I was fascinated by how it walked on its hind legs, using its tail to balance.' Its strong forelegs, equipped with huge claws for digging out ants and termites, were held just above the ground. Tristan crept slightly ahead of the pangolin and lay on the ground to get a low angle. After about 20 minutes, it walked right past him, nose down, sniffing for prey, and Tristan grabbed his shot, using a spotlight to illuminate just part of it against the darkness. Two nights later, he found the same pangolin being harassed by a leopard, trying to bite and claw open the armoured ball. But the scales were too hard, and the leopard soon lost interest and left. Such armour, though, is no defence against electric fences or vehicles, and with human predators, rolling into a ball merely makes it easy to catch.

Canon EOS 7D + 70-200mm f2.8 lens; 1/200 sec at f2.8; ISO 400; spotlight.

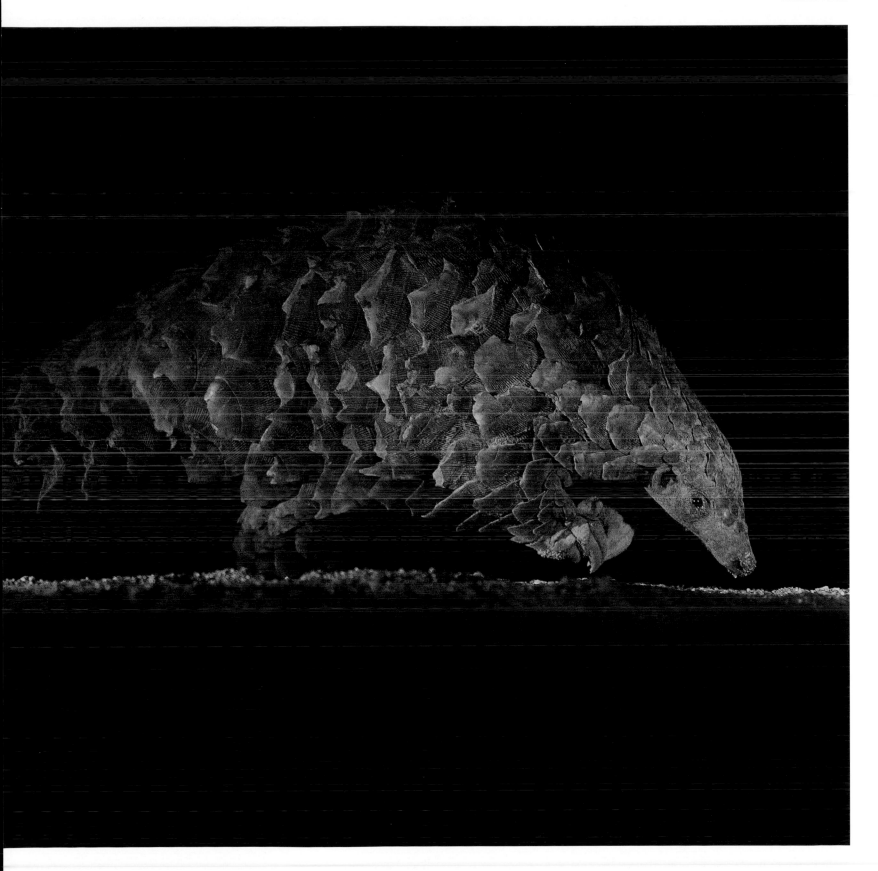

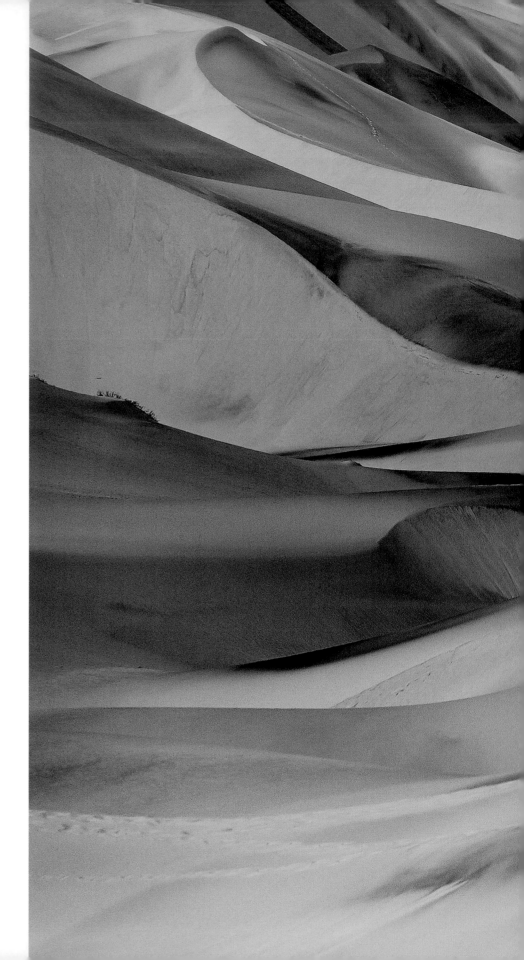

Desert survivor
Sergey Gorshkov
RUSSIA

When Sergey flew by helicopter over northern Namibia in December 2013 to photograph the dunes, he spotted many gemsbok – mostly dead. The worst drought for a generation had hit Namibia and Angola, following almost three decades of low seasonal rainfall and a second year of failed rains. Despite being well adapted to the arid environment – surviving without water for long periods, obtaining moisture from roots and tubers dug up with their hooves and allowing their body temperatures to rise a few degrees – many gemsbok had not made it. It was while flying along the Kunene River, one of Namibia's few perennial rivers, providing a water source for wildlife, that Sergey spotted a lone gemsbok in the dunes. The helicopter was flying high so as not to disturb the wildlife, and though the door was off the side for ease of photography, Sergey had only a couple of seconds to frame the image, trying to hold the camera steady while being buffeted by the wind. But he got the shot, a picture that captures the symbolic solitude of this remarkable survivor, set against the stark beauty of the vast dunes.

Nikon D4 + 70-200mm f2.8 lens; 1/8000 sec at f5.6; ISO 1000.

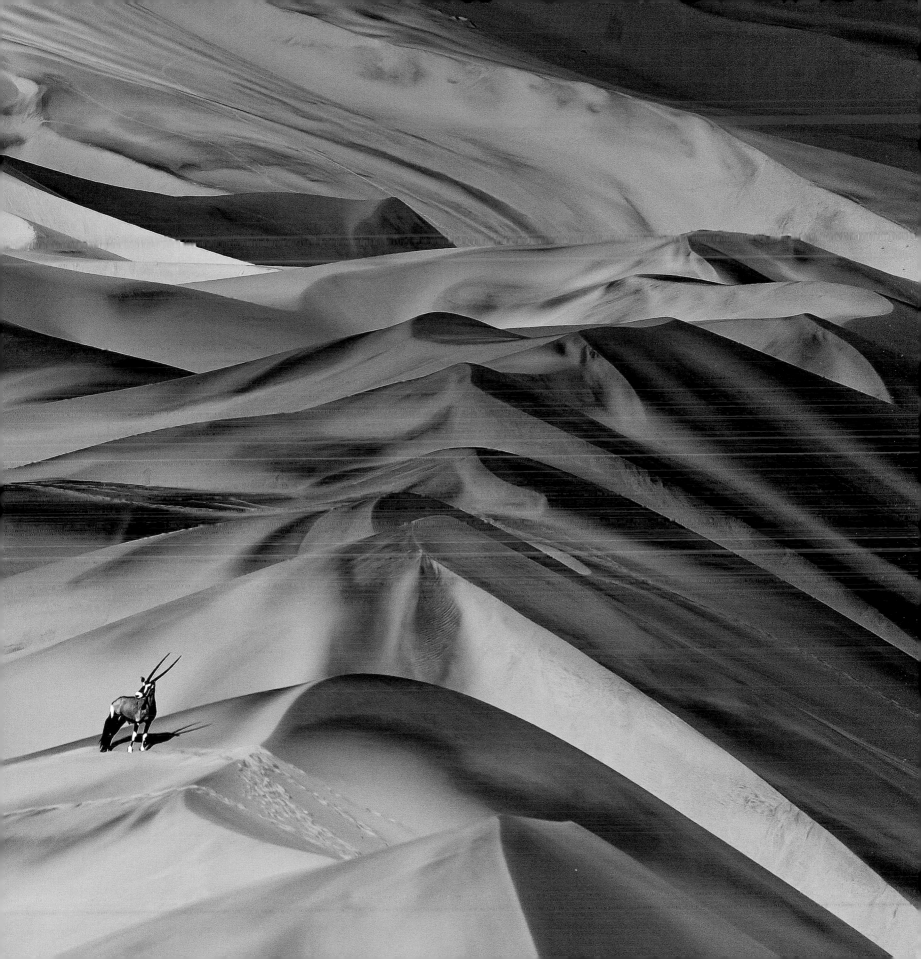

Snow hare
Rosamund Macfarlane

UK

One of Rosamund's photographic ambitions was to photograph Scottish mountain hares in the snow, camouflaged in their winter coats. Native to Britain, mountain hares moult from brown to white or partially white in winter, depending on temperature. With a local expert, Rosamund climbed a valley in the Scottish Cairngorms, 'at times through knee-deep snow', until they came across a couple of hares that allowed them to approach within photographic range. Their mottled, snow-dusted coats echoed the colours of the snow-covered hillside. For several hours, Rosamund lay on the ground in freezing temperatures, observing the hares snuggled into their forms (shallow depressions) as fine snow blew over them and rime coated their pelts. In the late afternoon, the hares finally became active and started to feed, scraping the snow from the heather and then nibbling the shoots. Positioning herself so that she was looking up a gentle incline directly at one hare, Rosamund captured its determined scrabbling in a head-on portrait.

Canon EOS-1D X + 100-400mm f4.5-5.6 lens + 1.4x extender at 560mm; 1/320 sec at f8; ISO 800.

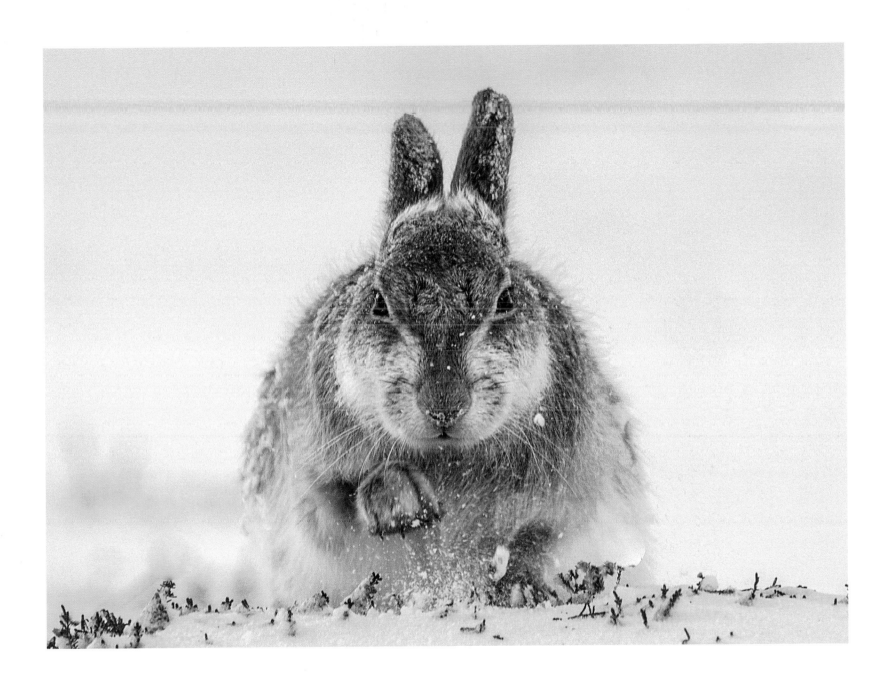

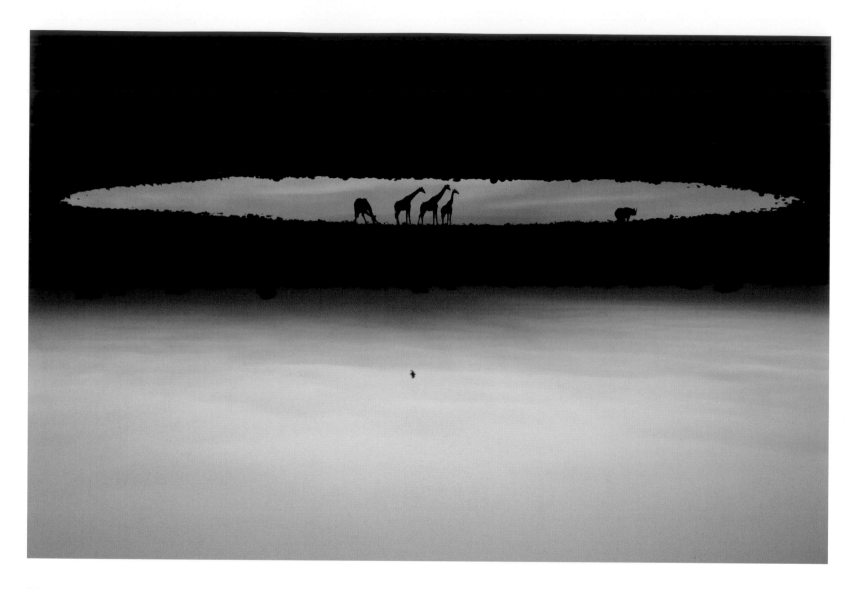

Heaven on Earth
Marina Cano
SPAIN

The giraffes arrived at the waterhole just after sunset and began to drink alongside a black rhino. It was Marina's first trip to Namibia's Etosha National Park, and she relished the timeless sunset scene she could see from the viewpoint at Okaukuejo Camp. The giraffes took turns to stoop in characteristic pose, splaying their forelegs to reach the water, while the black rhino just stood quietly. In the fading light, only the reflections of the animals' silhouettes were visible. To include all the waterhole reflections in her image, Marina climbed onto a bench and held her camera above her head. The composition came together as the giraffes aligned, one stooped to drink, the rhino stood in profile and a bird sailed past. Inspired to capture the magical atmosphere and avoid 'just another sunset shot', Marina flipped the image so the animals are the right way up, leaving the rest of the picture to intrigue our perception.

Canon EOS-1D X + 16-35mm f2.8 lens at 30mm; 1/160 sec at f5.6; ISO 1000.

Reflection in black
Petr Bambousek
CZECH REPUBLIC

This is an intimate portrait of a critically endangered primate – a Celebes crested macaque, found only on the Indonesian island of Sulawesi and nearby islands. It's also an image Petr deliberately set out to take. Travelling with a large troop of macaques in Tangkoko Nature Reserve, Petr would walk with them for up to 5 kilometres (3 miles) a day as they searched for food, mainly fruit but also vegetation and small animals. For most of the time the light was too bright to take the portrait shot he visualized, setting the amber eyes against the jet-black face and fur. His chance finally came when the group stopped to feed and rest and one young male sat down in the shade of a tree. 'He was intensely curious and sat watching me from just a few metres away,' recalls Petr. 'It was the expression in his eyes that fascinated me.' Petr deliberately underexposed the shot to accentuate the eyes and evoke the connection we have with other primates. What isn't visible is that the male has lost part of his arm, the result of being caught in a bird trap. The species continues to be threatened on Sulawesi by hunting for food (its meat is a local delicacy) and loss of its rainforest habitat to logging, agriculture and settlement.

Canon EOS 6D + 300mm f2.8 lens; 1/500 sec at f3.5 (-2.3 e/v), ISO 2500.

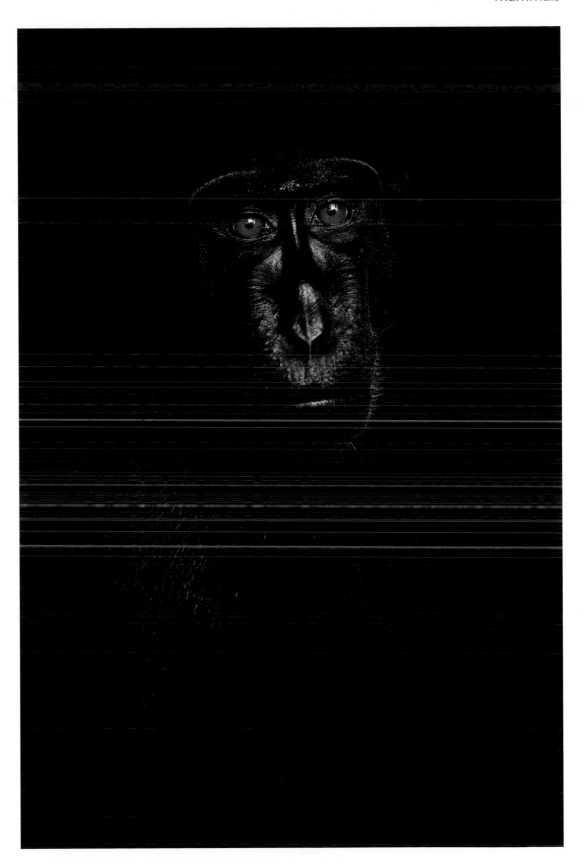

Land

Landscape in ash

Hans Strand

SWEDEN

Hans was flying by helicopter over southern Iceland's Fjallabak Nature Reserve in the highlands of Landmannalaugar, taking pictures for a book about Iceland's spectacular landscapes. Following a river valley, they flew under the clouds and, 'all of a sudden, this magical place appeared,' says Hans. Icefields and glaciers lined the flanks of the mountains. They were stained with volcanic ash, recording in layers of intensity the details of the flowing movements of snow and ice. It's a region known for its volcanic activity, but with no eruptions in the past few years, the fine ash could have been deposited there by wind from elsewhere. The mist meant that Hans had to shoot at a relatively low speed, but being a veteran aerial photographer, he kept the camera steady, and the low light enhanced the subtle colours of the otherworldly landscape.

Hasselblad H3DII-50 + 50mm lens; 1/500 sec at f3.4; ISO 200.

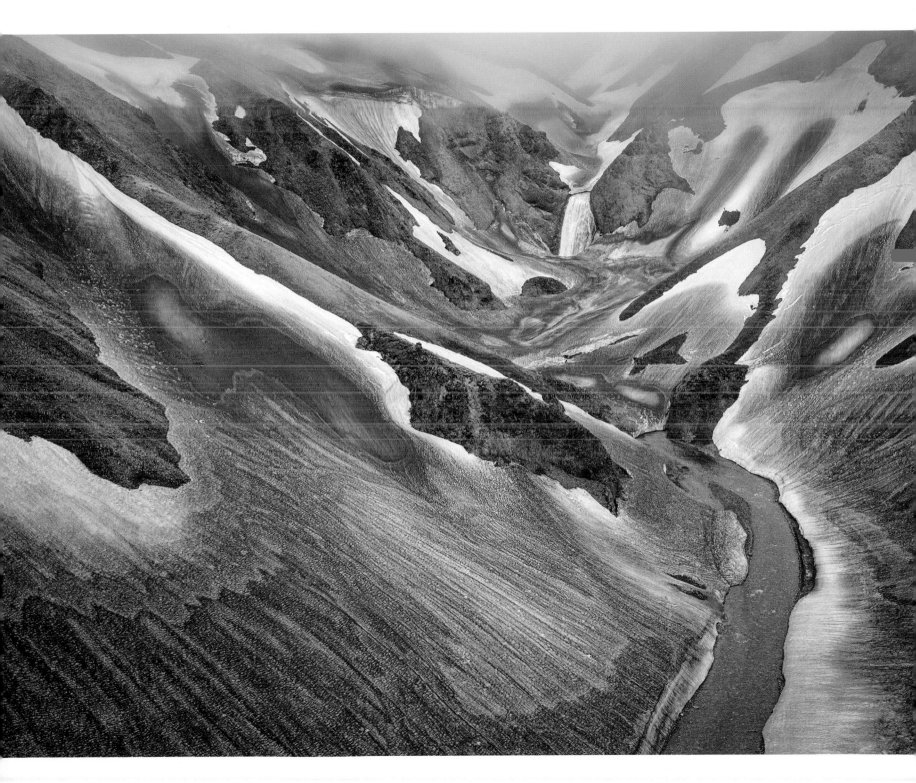

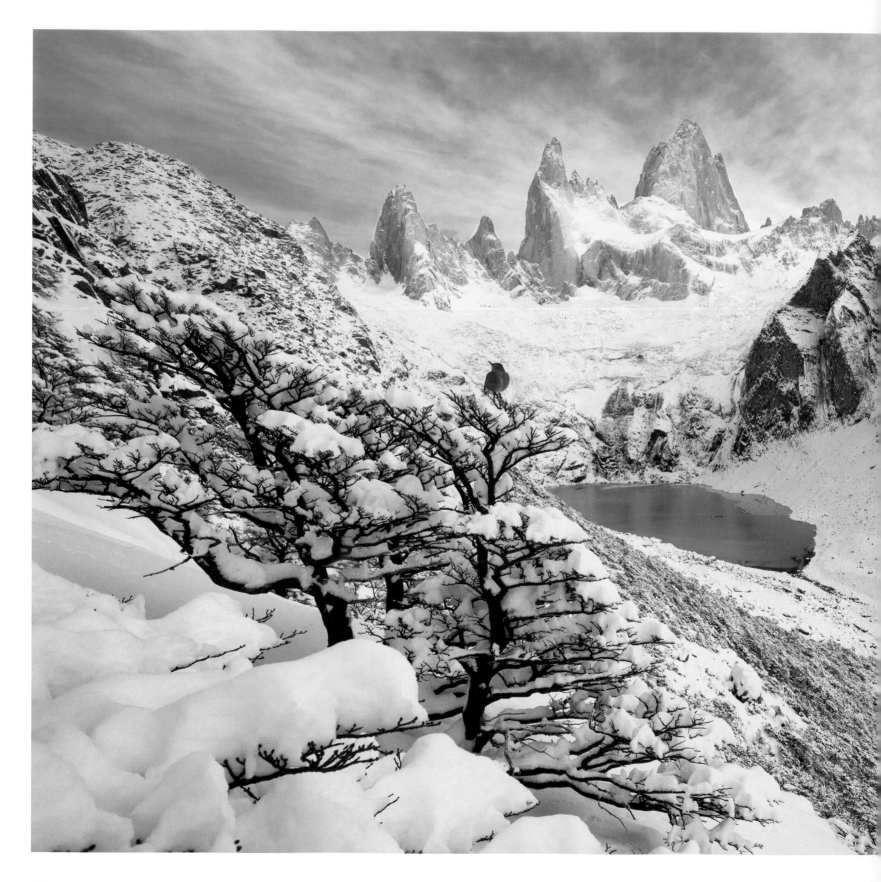

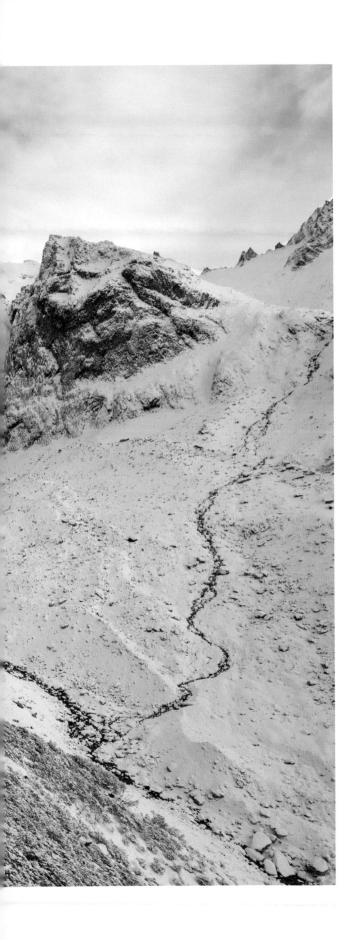

Jagged peace
Floris van Breugel

USA

'It was a rare opportunity,' says Floris, grateful to his companion, who was skilled at predicting weather patterns in this part of Patagonia. 'There was enough snow to stick to the trees but not so much as to make travel dangerous, no wind, an unfrozen lake and a clear view of Fitz Roy.' They had waited out a snowstorm before donning snowshoes and heading into the backcountry of Argentina's Los Glaciares National Park. A designated World Heritage Site, the park boasts the largest ice mantle outside Antarctica, with numerous glaciers, lakes and towering mountains. Mount Fitz Roy – also known as the 'smoking mountain', after the cloud that usually forms around its peak – is the highest, rising a jagged 3,375 metres (11,000 feet) above sea level. While Floris was scouting for compositions, a little bird showed up – a black-billed shrike-tyrant (named after the aggressive nature of some species in its tyrant flycatcher family). With fresh snow and muted light evoking the quiet wilderness, the bird completed the shot, adding a sense of scale and connection to the landscape.

Sony Alpha a7R + Nikon 14-24mm f2.8 lens; 1/125 sec at f16; ISO 200.

Collage of sand
Timo Lieber
GERMANY/UK

Alone in the world's largest sand desert, fascinated by its beauty and hostility, Timo was realizing his long-held ambition to photograph the desert environment. Rub' al Khali (the Empty Quarter) spans an area of the Arabian Peninsula larger than France, has less than 3 centimetres (1.2 inches) of rain a year, and temperatures that reach 51˚C (124˚F). Despite the oil and gas beneath its surface, it is free of human settlement – even the Bedouin stick to the edges, crossing only occasionally. Timo got a local guide to drop him off in the remote dunes. 'The key for me was to immerse myself in the landscape,' explains Timo. 'Camping on my own was the only option.' Over the next few days, he made forays on foot to take pictures. Enduring several sand storms, he was rewarded with this collage of feldspar-tinted contrasting sands, bathed in the early morning light.

Canon EOS 5D Mark II + 400mm f5.6 lens; 1/125 sec at f16; ISO 200; Gitzo tripod.

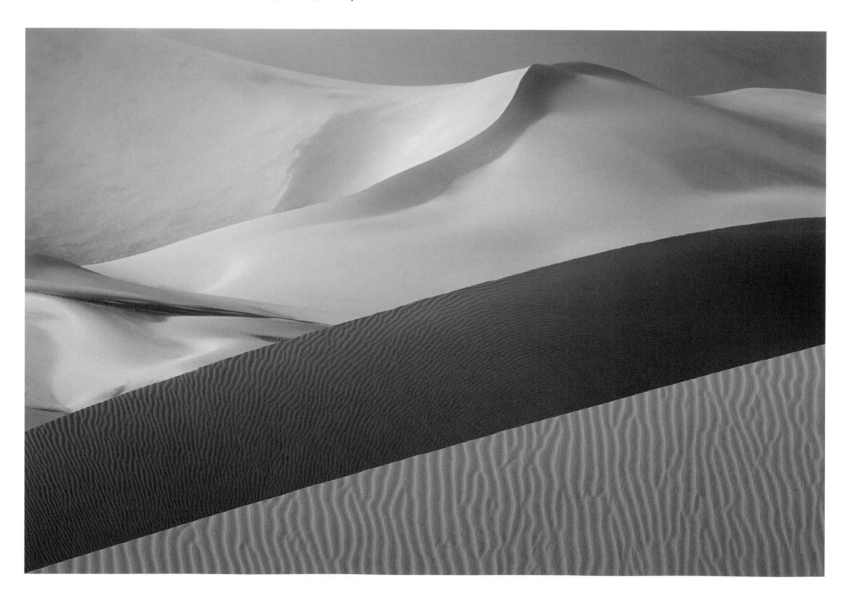

The art of spiders
László Novák
HUNGARY

Driving along a highway in western Hungary, László just had to stop the car. The wetland beside the road was completely covered in gossamer, shimmering in the dawn sunlight like some giant conceptual artwork. The silk sheets were the remains of the parachuting strands used by millions of tiny 'money' spiders as they rode the wind to disperse to new areas. Dispersing spiders climb to the tops of plants, stick up their abdomens and extrude silk strands from their spinnerets into the wind. On a relatively still day, the spiders are not carried far, as here, or the strands may just festoon surrounding vegetation. Returning to the site over several mornings, László used a wide-angle lens to highlight the expanse of silk covered with dew, and on the one day he was gifted with a pink sunrise filtering through the early morning mist, he captured this otherworldly scene.

Canon EOS 5D 17-40mm f4 lens at 25mm; 10 sec at f22; ISO 200; Giotto tripod.

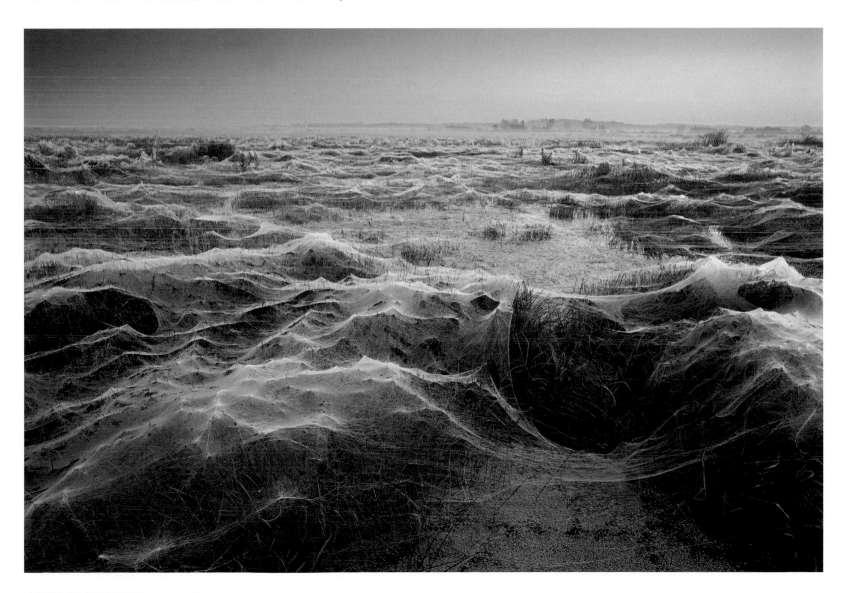

The tunnel of spring

Ugo Mellone
ITALY

Timing and planning were crucial for this photograph. In winter, snow covers the heights of southern Spain's Sierra Nevada (the name means 'snow-covered mountains'), but in spring, as the Mediterranean sun rises, it melts fast. Melting takes place under the snow as well as above, and with light, the vegetation starts to grow, helping to raise the temperature. Ugo had heard stories from mountaineers of huge snow tunnels forming as the meltwater runs off the peaks. He also knew that these tunnels last only a short time, depending on the temperature and snowfall that winter. Bad weather delayed the start of his expedition, and he was possibly a little late, as he found only one tunnel large and safe enough to photograph inside. But this one was like a huge greenhouse, with light percolating through part of the roof. Protected from the gale-force winds outside, Ugo was able to set up his tripod and use a long exposure to freeze the movement of the little waterfall. He wanted to convey a sense of mystery and show the stream as nurturing a spring oasis. In fact, meltwater streams nurture all the meadows that can be found in the otherwise barren mountain heights and then cascade down to join the Guadalquivir River, which eventually waters the world-famous Coto Doñana wetland on the Atlantic coast.

Canon EOS 7D + 12-24mm f4 lens; 1.3 sec at f13; ISO 100.

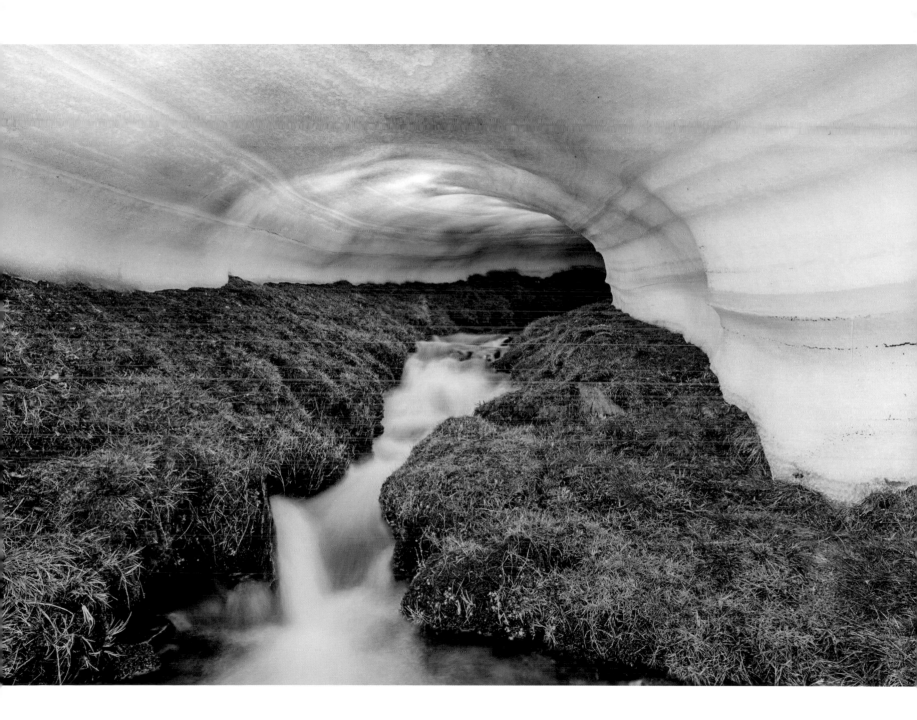

Urban

Shadow walker
Richard Peters
UK

A snatched glimpse or a movement in the shadows is how most people see an urban fox, and few know when and where it goes on its nightly rounds. It was that sense of living in the shadows that Richard wanted to convey. He had been photographing nocturnal wildlife in his back garden in Surrey, England, for several months before he had the idea for the image, given to him by the fox when it walked through the beam of a torch he had set up, casting its profile on the side of his shed. But taking the shot proved to be surprisingly difficult. It required placing the tripod where he could capture both the cityscape night sky and the fox silhouette, a ground-level flash for a defined shadow, a long exposure for the stars, a moonless night to cut down on the ambient light and, of course, the fox to walk between the camera and the wall at the right distance to give the perfect shadow. On the evening of this shot, the neighbours switched on a light just before the vixen arrived, unaware of her presence but adding to the image.

Nikon D810 + 18-35mm lens at 32mm; 30 sec at f8; ISO 1250; Nikon SB-800 flash; Gitzo tripod + RRS BH-55 ballhead; Camtraptions PIR motion sensor.

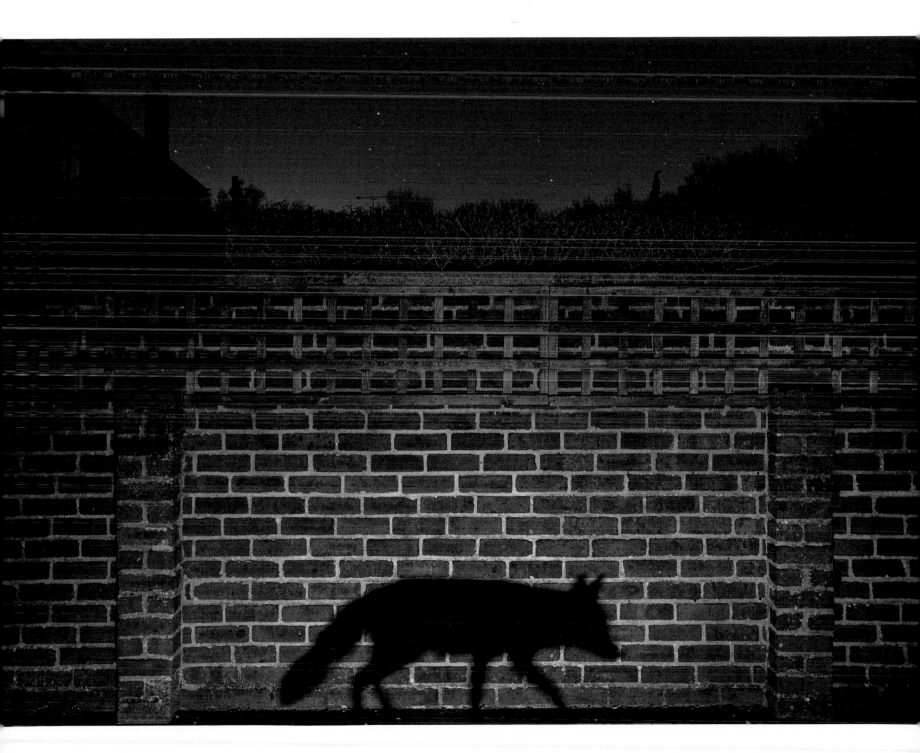

Stork art
Francisco Mingorance
SPAIN

White storks seem equally at home on artificial structures as they are in trees, often nesting on rooftops and telegraph poles. Francisco discovered three pairs high on this sculpture outside the Vostell-Malpartida Museum near Cáceres in Spain. The installation, by German artist Wolf Vostell, incorporates a Russian MiG-21 aircraft, two cars, pianos, computer monitors – and now, three huge nests, which the storks use each year, migrating from their overwintering grounds in southern Africa. Francisco wanted a picture of the storks sleeping under a starry sky, but there was too much light. 'I got special permission for most lights to be shut down,' he says, 'but then the storks kept moving about and flying off.' Using a long exposure, he got just one shot he liked, with the storks quietly asserting their place in the modern world that Vostell depicted.

Canon EOS-1D X + 70-200mm f2.8 lens; 7.8 sec at f2.8; ISO 1600; intervalometer; tripod.

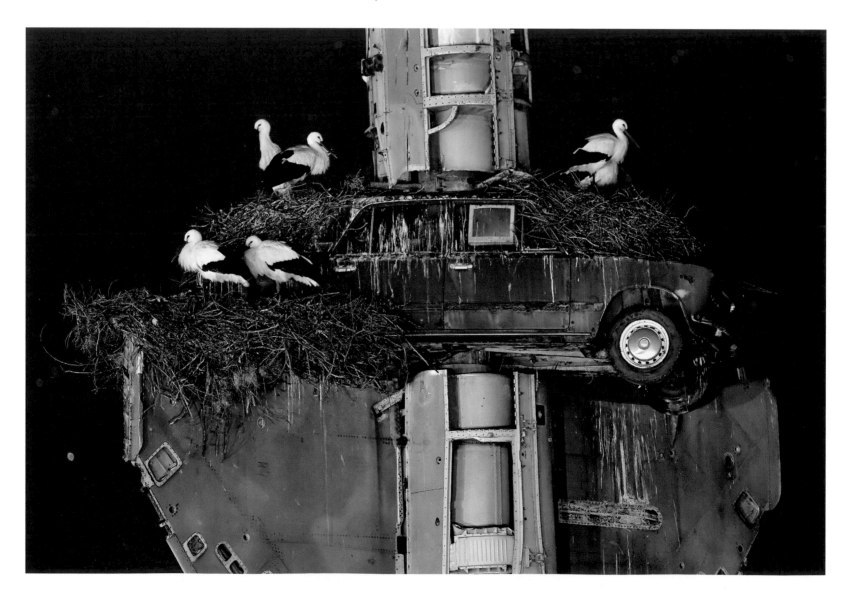

The blizzard of birth and death
José Antonio Martínez
SPAIN

In a swarm of mayflies so thick that at times he couldn't see, with insects in his ears and mouth, José had to act fast to record a frenetic mating gathering that would last barely 10 minutes. 'It feels', he says, 'as though you are in a gale, brushed by millions of silken wings.' Every night, between mid-August and mid-September, he stakes out this bridge over the River Ebro in Tudela, northern Spain, waiting for the breathtaking spectacle that belies a tragedy. Suddenly, millions of adult mayflies start to emerge en masse from the river where they developed as larvae and head for romance under the light of the street lamps. The females then seek to lay their eggs on water before their brief lives end. But the lamplight reflected from the road surface resembles moonlight reflected on the river surface, causing the mayflies to make a fatal mistake – depositing their eggs in vain on the road.

Canon EOS 5D Mark II + 70-200mm f4 lens at 200mm; 1/50 sec at f4; ISO 1600.

Little fox in the big city
Neil Aldridge
SOUTH AFRICA/UK

From his window, Neil watched the fox head out of the London park on its nightly rounds, cross a busy road and slip down an alley into a courtyard. As it triggered a security light, Neil saw the picture he wanted to create, as part of a story on the polarized relationships the British have with the red fox. To get the angle, he used a wide-angle lens and hung his camera on a tripod out of the window and against the wall. But for weeks, driving rain deterred both Neil and the fox. As the weather improved, the waiting began. 'The fox would show up any time between 10pm and 4am,' says Neil. He needed it to be in front of the security light, and rather than bait it with food and bring the animal to the attention of its human neighbours, he wiped pungent fish oil onto the ground. The fox was enticed to stand still just long enough for this exposure, revealing it in its urban environment.

Canon EOS 5D Mark II + 16-35mm f2.8 lens at 16mm; 1.6 sec at f7.1; ISO 1250; hähnel remote shutter release; Gitzo tripod + Manfrotto joystick head.

Cormorant cityscape

Frank Abbott

USA

Frank had spent the afternoon photographing birds coming and going from old pilings by a salt marsh on Florida's Santa Rosa Sound. As the sun set, the birds began to roost, mostly double-crested cormorants, with the odd brown pelican (second from right) and great egret (third from right). As the breeze died, the water calmed and filled with the reflected colours of the afterglow and nearby condominiums. 'I just needed to get in position to line it all up,' says Frank. The challenge for him was the timing. He is paralyzed from the waste down after a spinal-cord injury sustained while diving. 'With a wheelchair full of me and camera equipment, off I went into the salt marsh – the afterglow-clock ticking.' Manoeuvring to perfect the composition, he pushed his tripod into the mud and then set the camera with a narrow aperture to maximize the depth of field (amount in focus). Slightly increasing the exposure time to give the tranquil water an ethereal quality, he still managed to capture the birds' silhouettes on the old pilings offset by the backdrop of modern towers. So absorbed was he in capturing the magical moment that he didn't notice his chair had sunk into the marsh almost up to its axles.

Nikon D800 + 300mm f2.8 lens; 1/15 sec at f22; ISO 320; remote shutter release; Induro tripod.

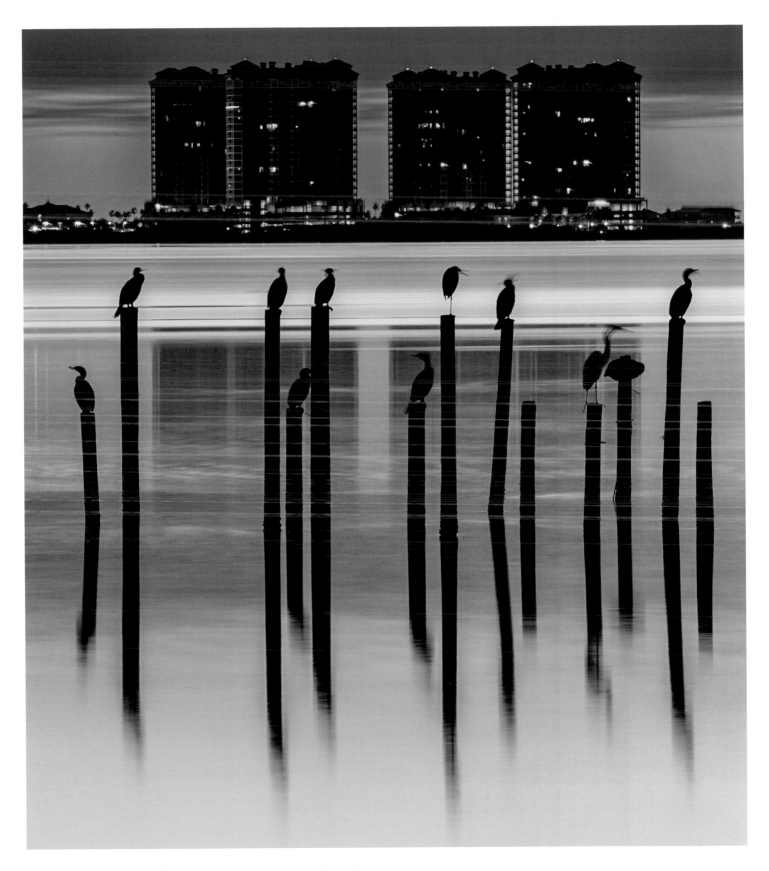

From the Sky

The art of algae

Pere Soler

SPAIN

The Bahía de Cádiz Natural Park on the coast of Andalucia, Spain, is a mosaic of marshes, reedbeds, sand dunes and beaches, which attracts great numbers of birds, and in spring it is an important migration stopping-off point. Pere was there for the birds but also for a spring phenomenon, only fully visible from the air. As the temperature warms and the salinity changes, the intertidal wetlands are transformed by colour as bright green seaweed intermingles with multicoloured microalgal blooms. White salt deposits and brown and orange sediments coloured by sulphurous bacteria and iron oxide add to the riot of colour. The full display usually lasts only a few weeks in May or June, but it's not possible to predict exactly when. Pere took his chances in June, hired a plane and, at midday, when the tide was out and the light was overhead, he was able to photograph the rich tapestry of colour and texture. The spectacle was, said the pilot, the most beautiful he'd seen in many years of flying over the delta.

Canon EOS 5D Mark III + 70-200mm f4 lens at 70mm; 1/1000 sec at f5.6; ISO 200.

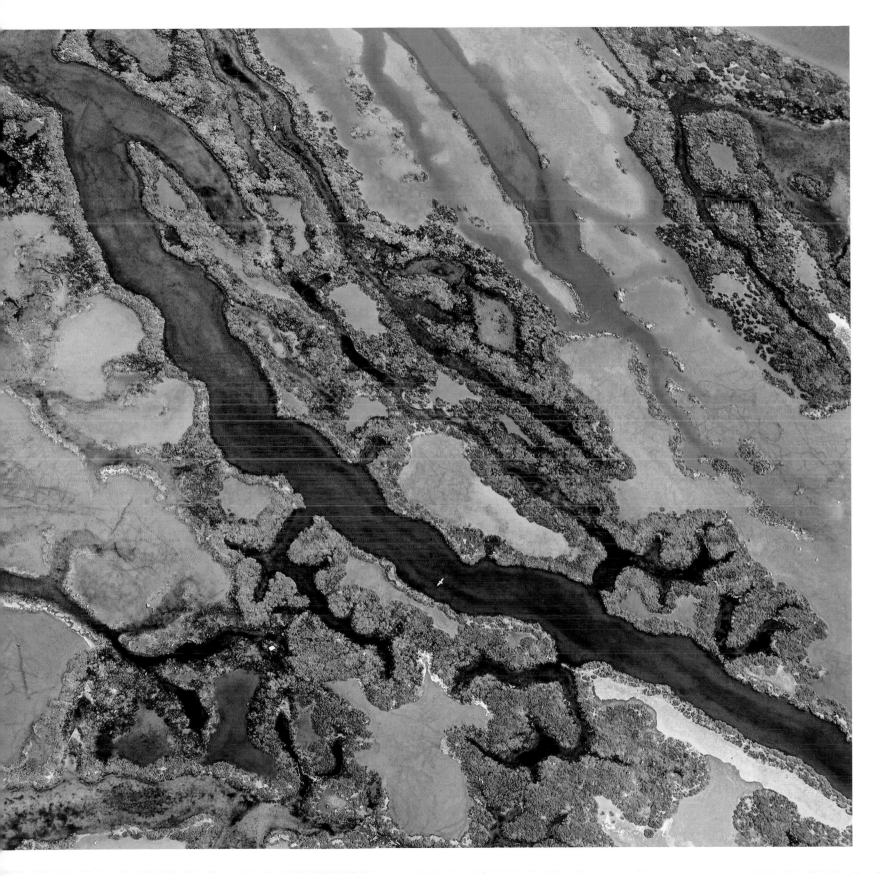

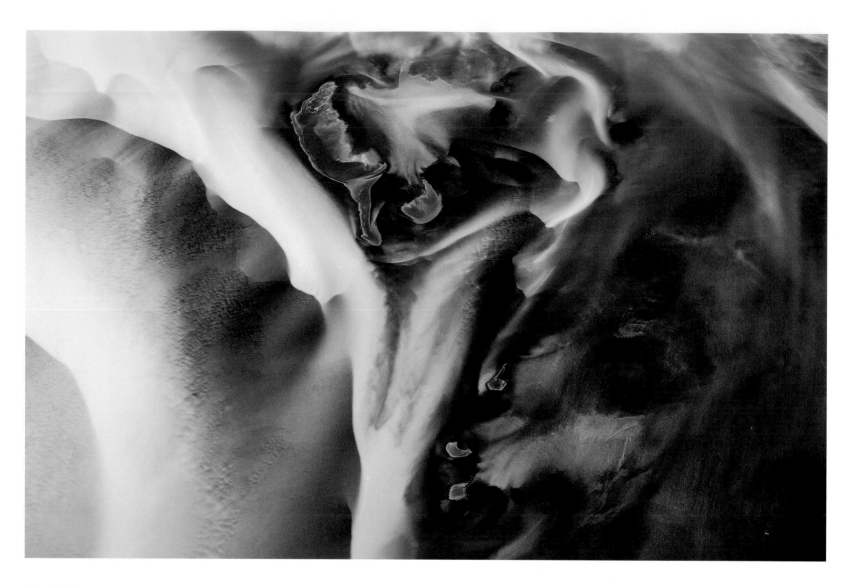

Meltdown
Daniel Beltrá

SPAIN/USA

Only on two days out of twelve was the Icelandic weather good enough to fly and only once did the clouds part to reveal the spectacular canvas. 'The colours and textures were unlike anything I'd seen,' says Daniel, who was photographing the effects of global warming. More than 10 per cent of the country is covered by glaciers – and all are retreating. More and more land is becoming ice free every year as a result of recent accelerated summer melt. Recent research has also shown that the Earth's crust under Iceland is lifting up – as much as 3.5 centimetres (1.4 inches) a year – as the weight of ice decreases. Shooting through the open window of a small aircraft, Daniel captured the beauty of the the Ytri-Rangá River, the colours varying with the depth of water, punctuated by small sand bars, and visibly heavy with sediments, most released from the melting glaciers. His arresting image tells a story of the planet's transformation.

Nikon D800E + Zeiss Otus 55mm f1.4 lens; 1/1250 sec at f3.2; ISO 640.

Black snow
Daniel Beltrá

SPAIN/USA

The ice sheet near Ilulissat, western Greenland, is peppered with black-dust melt-holes and threaded with ribbons of blue meltwater. The dust (cryoconite) consists of mineral particles and ash blown by the wind, often from distant deserts and volcanic eruptions – and increasing amounts of soot. It is the soot (from fires, diesel engines and power plants) that is turning the ice black and reducing its reflectivity, increasing absorption of heat and significantly increasing the melt rate. 'I wanted to capture the granular detail,' explains Daniel, 'but finding precise locations was a challenge, as the ice is constantly moving.' Shooting from a twin-engine plane was also difficult, severely constraining the view but safer for flying low over an unforgiving surface. On the only day of good weather during his trip, Daniel captured this thought-provoking image, with its intentionally intriguing scale.

Nikon D810 + 70-200mm f4 lens; 1/2000 sec at f9; ISO 720.

Realm of the flamingos
Paul Mckenzie

IRELAND/HONG KONG

Spellbinding patterns form on the surface of Tanzania 's Lake Natron, one of the soda lakes in Africa's Great Rift Valley, as the chemicals come to the surface in the heat. Water temperatures can reach 60°C (140°F) – a combination of the daily heat and hot springs – and the concentration of carbonate salts from volcanic ash, caused partly by the high rates of evaporation, make the water so alkaline that it will corrode the flesh of most animals. Lesser flamingos are one of the few species to benefit from these hostile waters, nesting on the lake's mudflats as a way to keep their young safe from predators, though doing so is a risky business. Paul has been photographing East Africa's soda lakes and their charismatic pink residents for more than a decade. On this occasion, he was focusing on the monochromatic patterns when, from the corner of his eye, he spotted a group of flamingos passing beneath the plane with slow, graceful flaps. He had just a second to frame the image out of the open door and change the setting, using high-speed partly to compensate for the turbulence and also the speed of the plane itself, catching the birds at full wing stretch before they disappeared from view.

Canon EOS 7D Mark II + 70-200mm f2.8 lens + 1.4x extender; 1/8000 sec at f4; ISO 500.

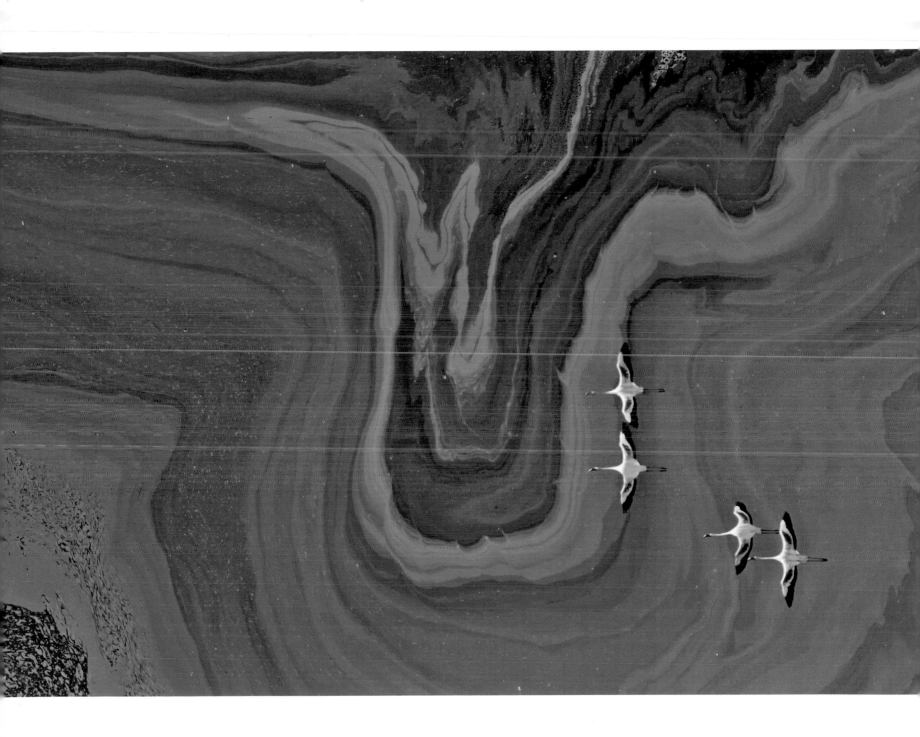

Flight art
Pascal Bourguignon

FRANCE

'Shooting pictures while flying a paramotor is always an exceptional experience,' says Pascal, but on this occasion he was in for a particular treat. It was early morning, and he was flying over an area he knew well, the Bay of the Fresnaye in Brittany, France. He was using the simplest of powered aircraft – just a paraglider wing, with a small motor driving a propeller, worn like a backpack. Light and easy to fly, it allowed him to pass back and forth, taking pictures from different angles and heights. 'The disadvantage is the lack of space for equipment. I take very little,' he says. 'Every flight is different, depending on the weather and the tides.' Looking for graphic compositions, he traced a small stream to where it carved its way through a sand bar left by the retreating tide. A flock of little egrets was feeding in the shallows, providing a sense of scale and completing the transient abstract design.

Fujifilm X-T1 + 55-200mm f3.5-4.8 lens at 200mm; 1/750 sec at f4.8 (-1 e/v); ISO 800.

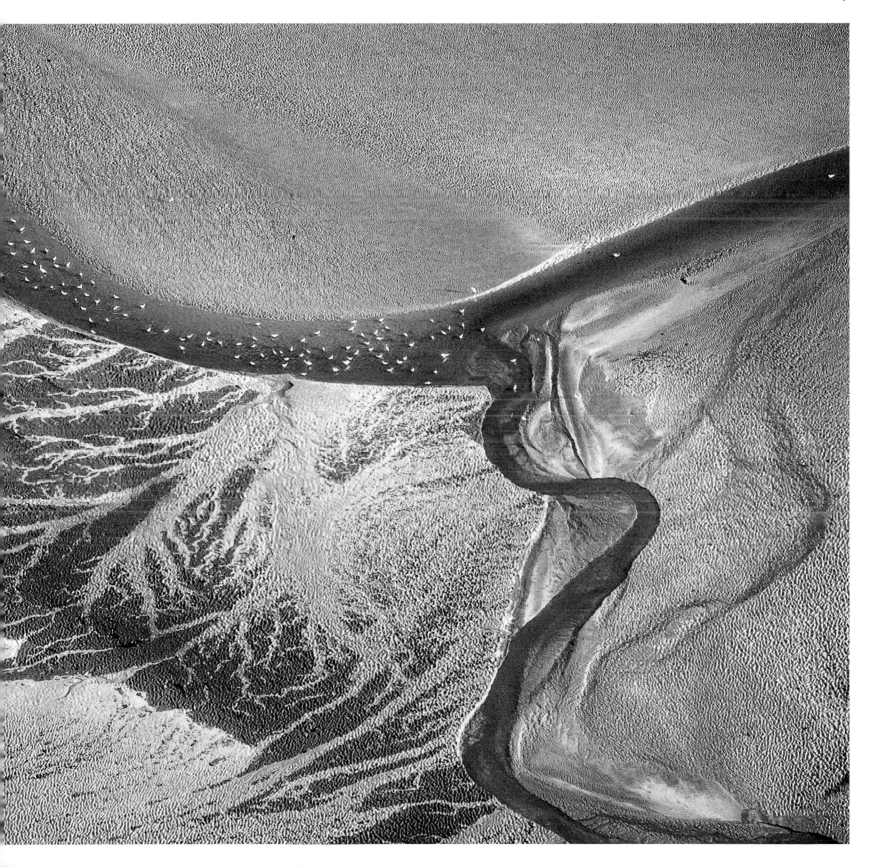

Under Water

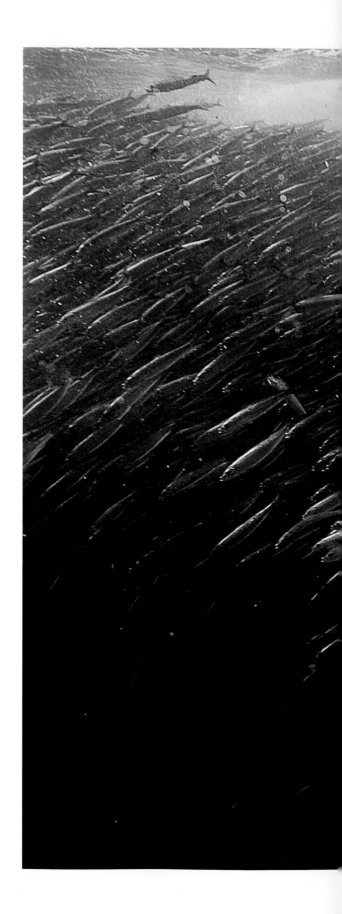

A whale of a mouthful
Michael AW
AUSTRALIA

A Bryde's whale rips through a swirling ball of sardines, gulping a huge mouthful in a single pass. As it expels hundreds of litres of seawater from its mouth, the fish are retained by plates of baleen hanging down from its palate; they are then pushed into its stomach to be digested alive. This sardine baitball was itself a huge section of a much larger shoal below that common dolphins had corralled by blowing a bubble-net around the fish and forcing them up against the surface. Other predators had joined the feeding frenzy, attacking from all sides. These included copper, dusky and bull sharks and hundreds of Cape gannets, which were diving into the baitball from above. The Bryde's whale was one of five that were lunging in turn into the centre of the baitball. Michael was diving offshore of South Africa's Transkei (Eastern Cape), specifically to photograph the spectacle of the 'sardine run' – the annual winter migration of billions of sardines along the southeastern coast of southern Africa. Photographically, the greatest difficulty was coping with the dramatic changes in light caused by the movements of the fish and the mass of attacking predators, while also staying out of the way of the large sharks and the 16-metre (53-foot), 50-ton Bryde's whales, which would lunge out of the darkness and, as he knew from experience, were capable of knocking him clean out of the water.

Nikon D3S +14-24mm f2.8 lens at 14mm; 1/250 sec at f9 (-1 e/v); ISO 800; Ikelite DS200 strobe; Seacam housing.

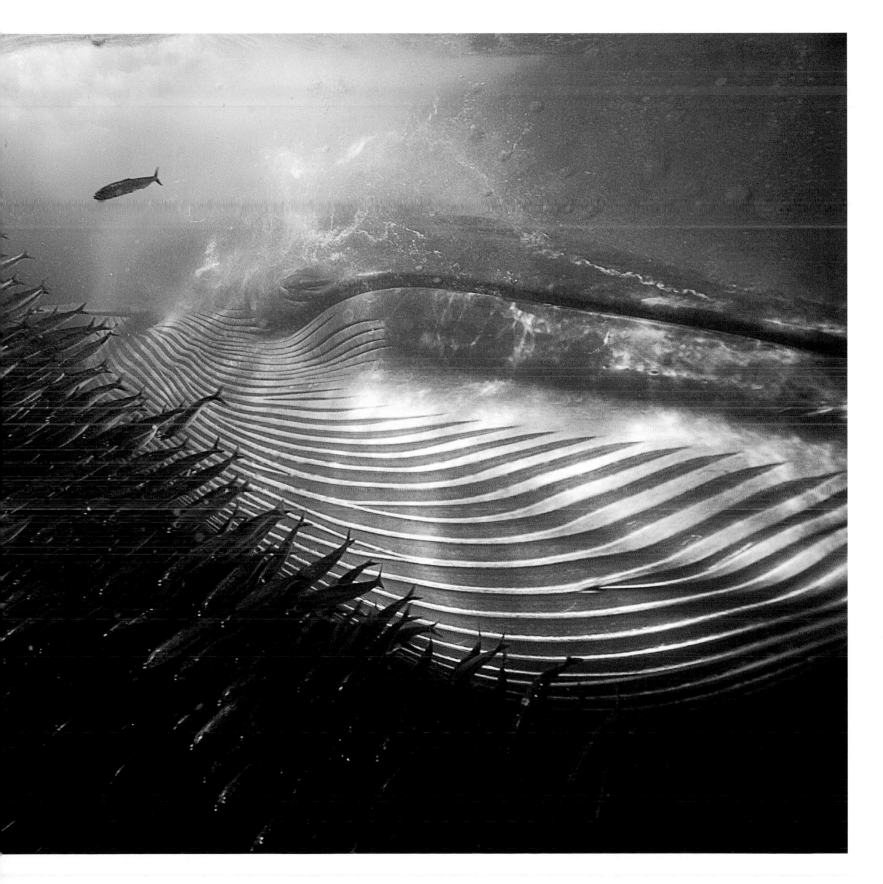

Rhythm of the blues
Cristobal Serrano

SPAIN

For Cristobal, photographing blue sharks was a dream come true. It involved a special trip to Faial Island in the Azores, and then a two-week wait for a sunny day with water clear enough to photograph the sharks. He chose the location, several kilometres off the coast, where shark-migration researchers had submerged a container of bait, but it was still a photographic gamble. Blue sharks travel vast distances – commonly up to 3,000 kilometres (1,700 miles) – utilizing major current systems, such as the Gulf Stream, to undertake their clockwise transatlantic migrations. They are also the most heavily fished sharks, with an unsustainable annual catch estimated at 20 million (mostly as longline and driftnet fishery bycatch), their fins being sold to the Asian market. 'I especially wanted a view looking down on them', explains Cristobal, 'to illustrate the beautiful, sinuous movement that characterizes their elegant swimming style.' The water clarity was perfect, but he had no point of reference, and while waiting for sharks to pass beneath him, it was a struggle to maintain his position and depth against the strong currents. Finally, two blues swam gracefully past, pilot fish in attendance, just 8 metres (26 feet) below, presenting him with the composition he had been waiting for.

Canon EOS 5D Mark III + 16-35mm f2.8 USM lens at 16mm; 1/125 sec at f7.1; ISO 500; Seacam housing.

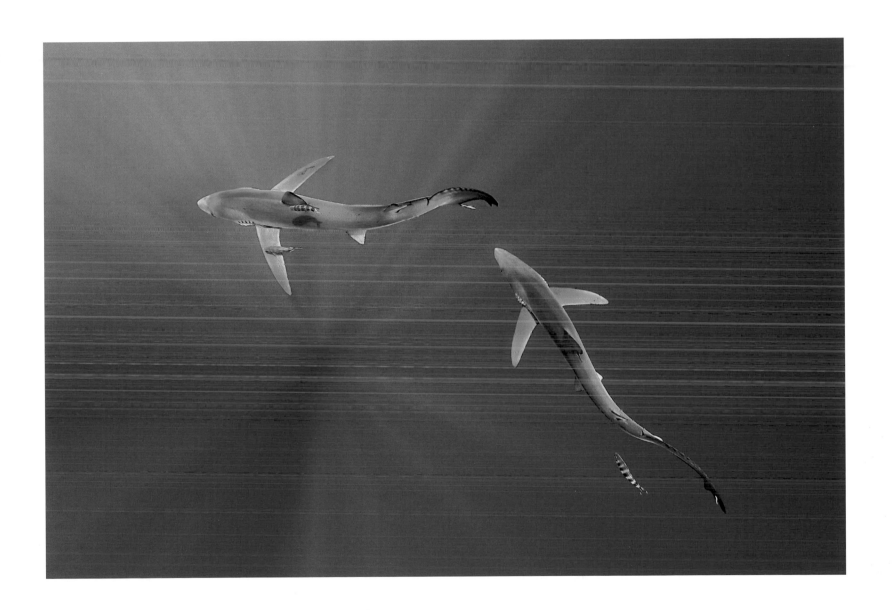

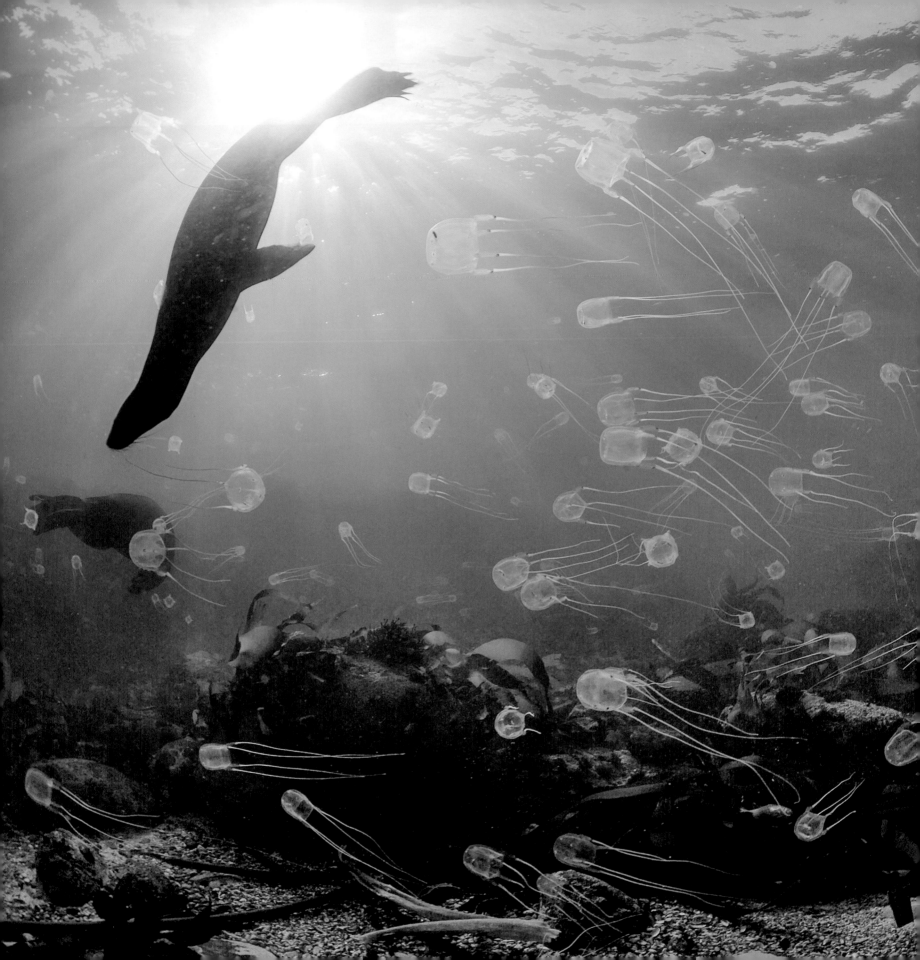

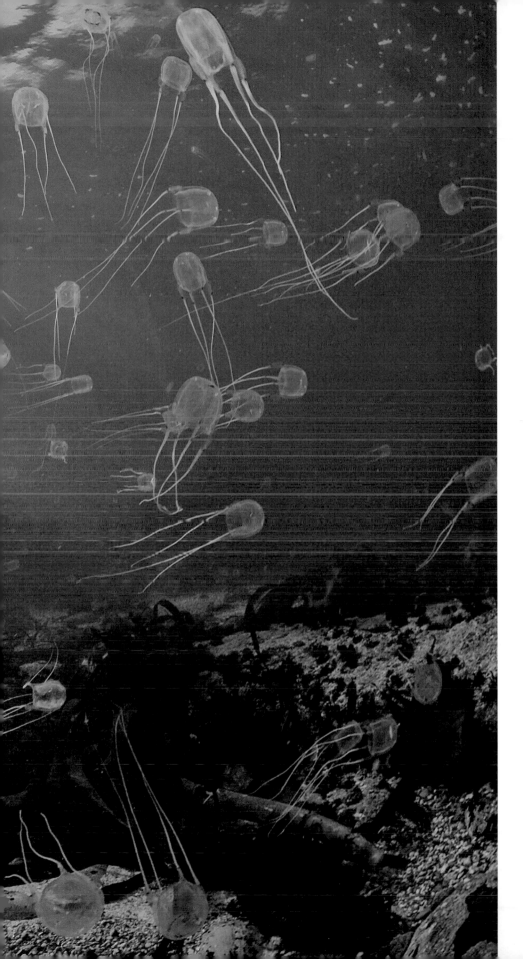

Just jellyfish
Thomas P Peschak
GERMANY/SOUTH AFRICA

'For years, I have been trying to make a photograph that foreshadows a world without fish,' says Tom, 'and this one evening, all the elements aligned.' He had been photographing Cape fur seals around Duiker Island off South Africa's western coast when the current propelled a large number of Cape box jellyfish into a sheltered bay, and he quickly refocused his attention. Jellyfish populations have increased substantially in many parts of the world, with overfishing and climate change thought to be the main causes. (In 2005, a nuclear reactor north of Cape Town lost power when an unusually high number of jellyfish were sucked up with the seawater needed to cool the power station.) Warmer waters stimulate growth and reproductive potential, while overfishing reduces the abundance of fish, notably sardines and anchovies, that prey on plankton, including juvenile jellyfish. In turn, jellyfish eat the eggs and larvae of these fish, reducing their populations even further. The consequences ripple through the food web, with predators such as Cape fur seals most affected. Their diet includes a lot of plankton-eating fish but not jellyfish. The sun was low on the horizon as the playful sealions darted through the tangled maze of tentacles, allowing Tom to capture this vision of a future ocean dominated by jellyfish.

Nikon D3S + 16mm lens; 1/250 sec at f18; ISO 320; Subal housing; x2 Inon strobes.

It came from the gloom

Jordi Chias Pujol

SPAIN

Jordi had just five minutes at a depth of 40 metres (130 feet) to look for subjects to photograph. The water in the deep, glacier-fed Lemaire Channel, cutting between the Antarctic Peninsula and Booth Island, was too cold to stay in longer, and the risks from decompression after a long dive were especially unwanted this far from medical help. It was his second dive beside a vertical rock wall, where he had seen many fascinating creatures. This time he was rewarded with a beautiful *Atolla* jellyfish – a deep-sea species of crown jelly, with a grooved bell not more than 15 centimetres (6 inches) across. Its ability to produce bioluminescent flashes when under attack (thought to lure other predators to see off its attacker) gives it the nickname of 'alarm jellyfish', and in the dark depths, its red colour renders it invisible. Jordi pointed his camera up towards the surface, using strobes to illuminate the jellyfish in the gloom and also gently lighting the 'fingers' of Antarctic octocorals on the wall. When a group of penguins zoomed across the frame, 'I shot instinctively,' says Jordi, 'just managing to catch the last one.' The outline of the gentoo penguin, identifiable by its characteristically prominent tail, added perspective to this otherworldly glimpse of polar-sea life.

Canon EOS 5D Mark II + 8-15mm f4 lens at 15mm; 1/100 sec at f10; ISO 320; Seacam housing; x2 Seaflash 150D strobes.

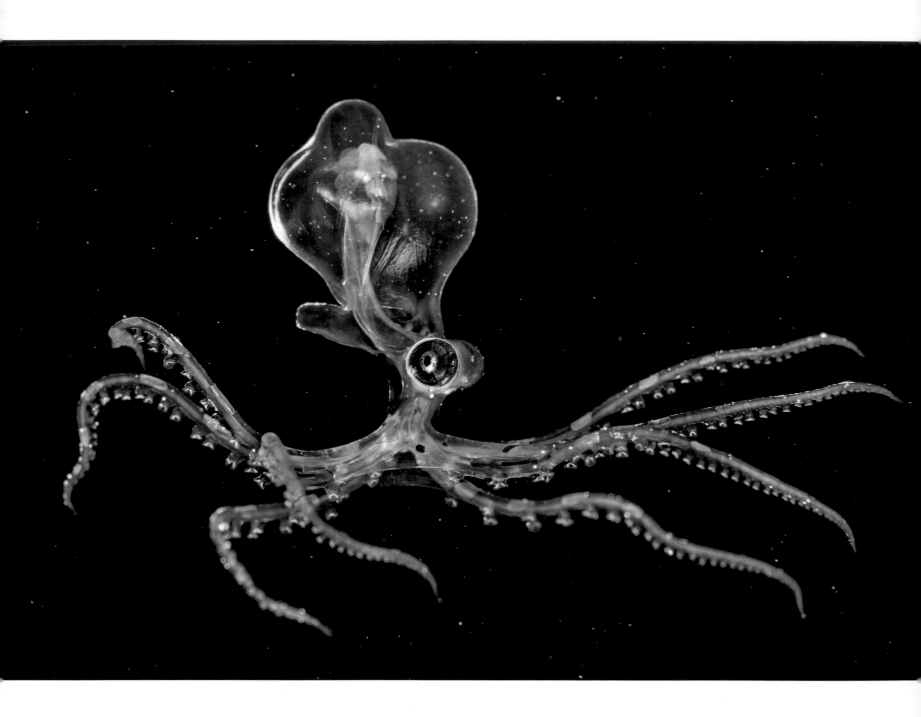

It came from the deep

Fabien Michenet

FRANCE

Fabien spends many hours diving at night in deep water off the coast of Tahiti, French Polynesia, where he lives. He is fascinated by the diversity of tiny creatures that migrate up from the depths under cover of darkness. These zooplankton feed on the phytoplankton found near the surface (which need sunlight to photosynthesize) and are themselves hunted by small predators that follow their ascent. One night, about 20 metres (66 feet) below the surface, in water 1,000 metres (3,300 feet) deep, some juvenile octopuses – just 2 centimetres (an inch) across, swam into view. 'One of them stopped in front me,' says Fabien, 'waving its tentacles gracefully, perhaps taking advantage of my lights to hunt the little crustaceans that were swimming around.' Its body was transparent – camouflage for the open ocean – revealing its internal organs. Chromatophores (colour-changing cells) were visible on its tentacles, possibly for use in the light, when a different kind of camouflage would be needed. By keeping as close as possible and drifting at exactly the same speed as the diminutive octopus, and taking care not to upset its natural behaviour with strong lighting, Fabien was able to capture his eye-to-eye portrait.

Nikon D800 + 60mm f2.8 lens; 1/320 sec at f18; ISO 200; Nauticam housing; x2 Inon Z-240 strobes.

Details

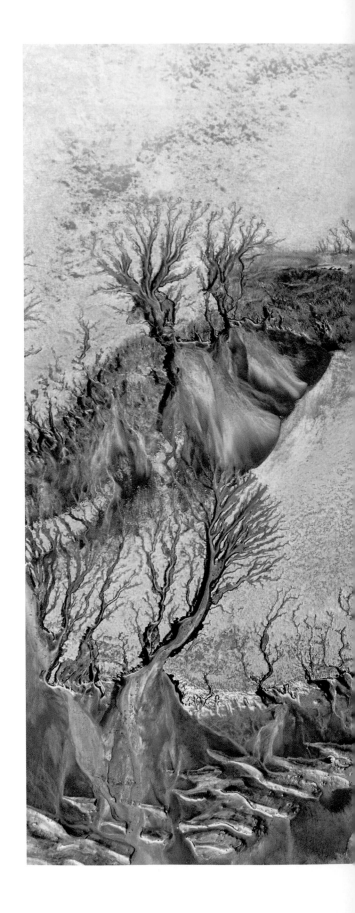

The meltwater forest
Fran Rubia

SPAIN

There was magic in the mud. As Fran watched, invisible forces sketched a picture on the ground right in front of his boots. Meltwater from Iceland's Vatnajökull glacier, filtering through the soil on a gentle slope, set mud granules of a specific density into motion. Trunks, branches and twigs formed until an entire forest had been created in the patch of mud, and trickles of water transformed into rivers running through the woodland. Fran waited for the shadow of the huge glacier behind him to fall on the scene and give a uniform light, and then he composed his image so that the 'trees' would appear to stand up out of the mud, as in a child's pop-up picture book.

Canon EOS 6D + 24-105mm lens at 35mm; 1/8 sec at f8; ISO 400; Manfrotto 190X tripod.

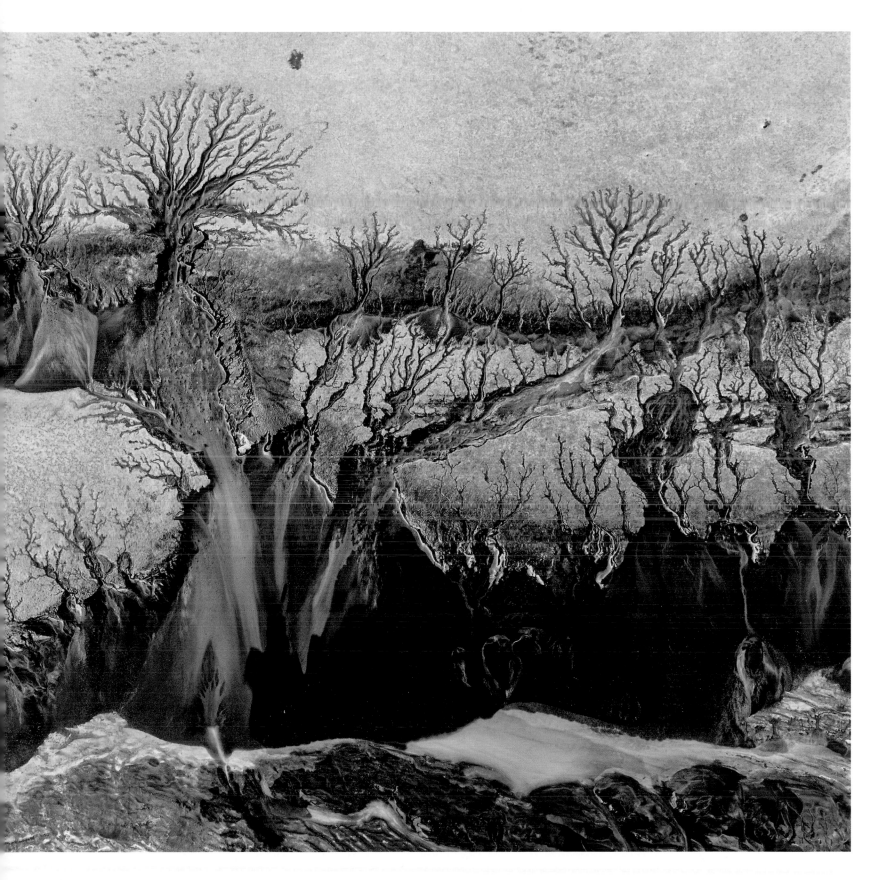

Colours in ice
Dag Røttereng
NORWAY

'It is rare to find a pond with a surface of solid ice that's crystal clear,' says Dag. 'When it does happen, the ice is usually too thin to walk on, and snow covers it quickly.' But on a trip to the Norwegian island of Smøla, following several cold days with no snow, he found a pond with thick, clear ice, and seized the opportunity. Looking for complementary colours, with lines and patterns, he ventured several metres out onto the ice to where he could see the most bubbles and leaves frozen beneath the surface. 'The yellow leaves crossing a blue ice crack gave a feeling of added depth,' he explains. By keeping the camera at a slight angle and using a polarizing filter, he minimized reflections from the surface, and he framed the shot with a square crop in mind.

Nikon D800 + 28-105mm f3.5-4.5 lens at 70mm; 2.5 sec at f25; ISO 200; Photo Clam tripod.

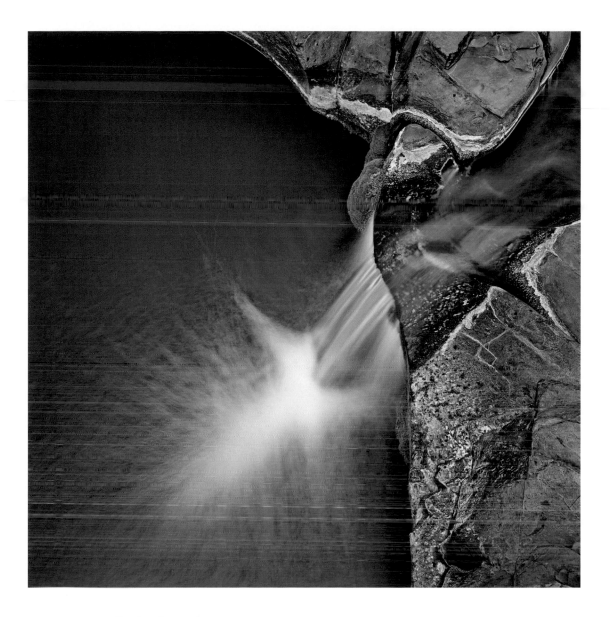

Splash point
Sheldon Pettit

AUSTRALIA

Rather than photograph the dramatic Hamersley Gorge itself, Sheldon chose to illustrate the beauty of a tiny waterfall flowing into the famous Spa Pool far below. Situated in Karijini National Park, Hamersley is one of many breathtaking gorges in this part of Western Australia, carved through rocks more than 2,500 million years old and boasting numerous waterfalls and pools. What fascinated Sheldon was the detail of the rocks as well as the power of such a small flow of water. He positioned his tripod to get an aerial perspective, set a long exposure to blur the water, focused on the rocks' pattern and framed the picture as a square so the impact of the water became central to the composition.

Phase One 645DF + IQ180 Digital Back + Schneider 80mm f2.8 lens; 4 sec at f8; ISO 35; Induro tripod + ballhead.

Ice-cave art
Floris van Breugel
USA

It was pitch black, cold and slippery in this part of the cave, but the darkness hid a multitude of forms and colours trapped within a layer of ice almost a metre (three feet) deep, which Floris was determined to photograph. He had squeezed into the lower level of one of the many lava-tube caves in California's Lava Beds National Monument. When volcanic lava flowed 30,000–40,000 years ago, the top of some flows cooled and crusted over, while the lava beneath continued to move. When the eruption ceased, the flows carried on, draining and leaving hollow tubes. 'Simply shining a light on the ice would have created a distracting glare,' says Floris. Instead, he framed the scene he wanted, set his camera on the tripod for a three-minute exposure and then lit the scene by pointing his flashlight just above the surface and crawling across the ice to illuminate the rocks and bubbles in every part of the scene (though he was in the frame, he was not directly illuminated and so doesn't show up). Just before the end, he briefly lit the top layer of pale-blue bubbles from the side. 'It took countless attempts to get it right,' he explains, 'because the surface and underlying ice reflected light in different ways.' After eight hours work, he had this single exposure, illuminated exactly as he wanted.

Canon EOS 5D Mark II + 24-105mm f4 lens at 45mm; 176 sec at f16; ISO 400; Gitzo tripod + Markins ballhead; LED flashlight.

Angel wings
Ellen Anon

USA

Ellen woke one morning to find ice inside one of her windows. Temperatures in Pennsylvania, USA, had plummeted, and the cold had seeped in through a leaky window seal, causing moisture in the air to freeze on the inside of the glass. Covering the window with bubble-wrap to help warm the room, she took care not to disturb the crystals. Over the next few weeks, she photographed the frozen patterns that came and went, using natural light to avoid any reflections. 'Sometimes the sun had erased the designs by midday,' says Ellen, 'but each morning I'd get a new surprise.' Constrained by needing to put the camera square to the window to maintain overall sharpness, it was a challenge to frame the patterns she liked while avoiding background distractions from trees outside. Here a golden sunrise highlighting the crystal formations allowed her to capture the 'angel wings' that appeared in this intricate ice design.

Canon EOS 5D Mark III; 100mm f2.8 lens; 1/90 sec at f19; ISO 1600; Feisol tripod.

Black and White

The dynamics of wings
Hermann Hirsch

GERMANY

There's that moment, just as a white-tailed sea eagle grabs a fish from the sea, when to avoid plunging into the water it must switch flight mode, speed and direction to power upwards. Hermann set out to capture the dynamic beauty of that split second, choosing black and white to simplify the image to its essentials. This involved spending 26 days on a lake in Feldberger Seenlandschaft, Germany, photographing fishing white-tailed sea eagles. The challenge was to catch the moment when the sea eagle's wings are stretched forward, while showing enough of its beak and, crucially, the eye to make it recognizable as an eagle. Panning the camera along with the movement of the bird, on a slow shutter speed to blur the motion, he focused on the head. But it took more than 50 attempts to achieve his vision.

Canon 5D Mark III + 500mm f4 lens at 500mm; 1/50 sec at f8; ISO 200.

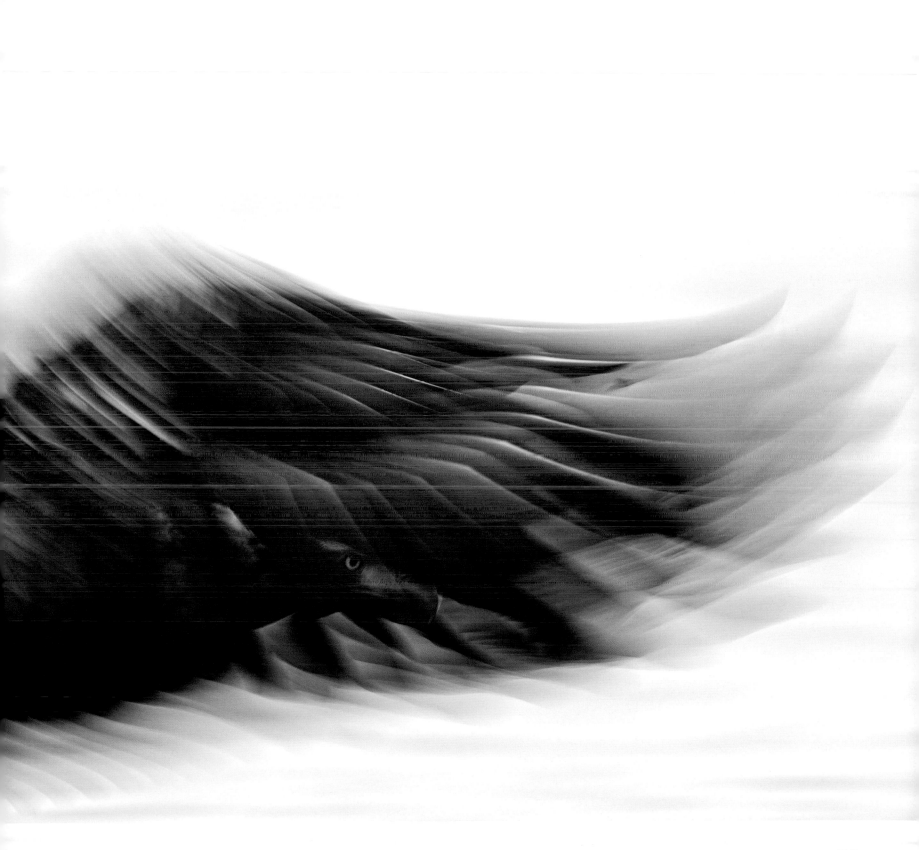

The apprentice

Nilanjan Das

INDIA

Loud cracks of horn against horn alerted Nilanjan to the action early one winter morning in India's Velavadar Blackbuck National Park. Through the mist, he could just make out two blackbucks engaged in what appeared to be a fight. As he approached, he could see that one was much younger, and that this was not a territorial fight. The older, darker male pushed and challenged, but whenever the juvenile stumbled, the adult stood back and waited. It appeared to be a training session, the adult – possibly a relative – allowing the youngster to prepare for the dangerous tussles of adulthood. Nilanjan used black and white and overexposed the image to express an encounter that he felt was gentle, possibly playful and more about bonds than conflict.

Nikon D800 + Sigma 300-800mm lens at 800mm; 1/15 sec at f20; Gitzo tripod; Wimberley head.

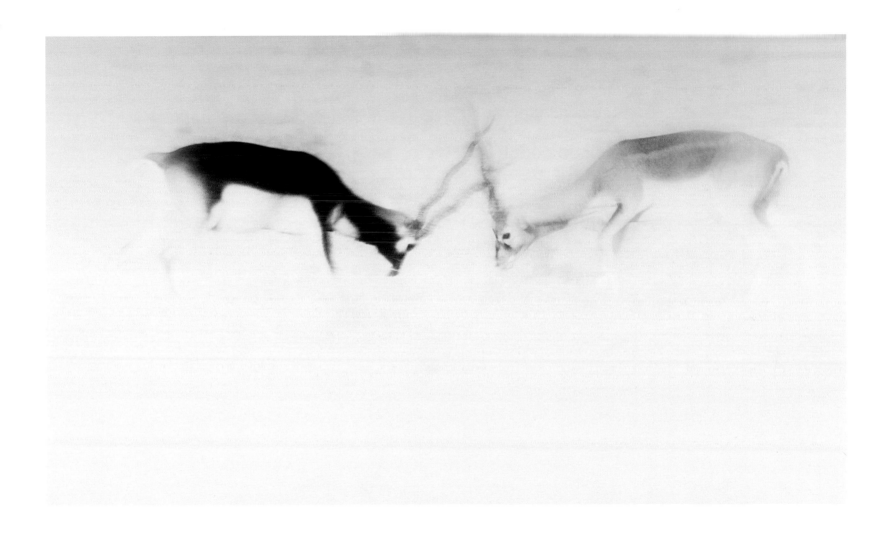

Flamingo doodles

Paul Mckenzie

IRELAND/HONG KONG

Lesser flamingos, icons of the soda lakes of Africa's Great Rift Valley, spend much of their time in huge social groups. When they're feeding (here on the estuary mud of Tanzania's Lake Natron) they spread out as they wade through the water, filtering algae through their bills. A thin layer of sediment-rich water covers the bed of black volcanic mud, which the flamingos disturb as they move slowly along, scribbling black lines through the reflections of the clouds. No sooner has one part of the trail faded than fresh ones appear. From above, the scene forms a living tableau. Paul has spent many years photographing the flamingos, often from the air and always 'in the context of this unique environment', he says. 'If I can do this in an artistic fashion, as I have attempted to do in this image, so much the better.'

Canon 5D Mark III + 24-105mm f4 lens at 60mm; 1/4000 sec at f4; ISO 800.

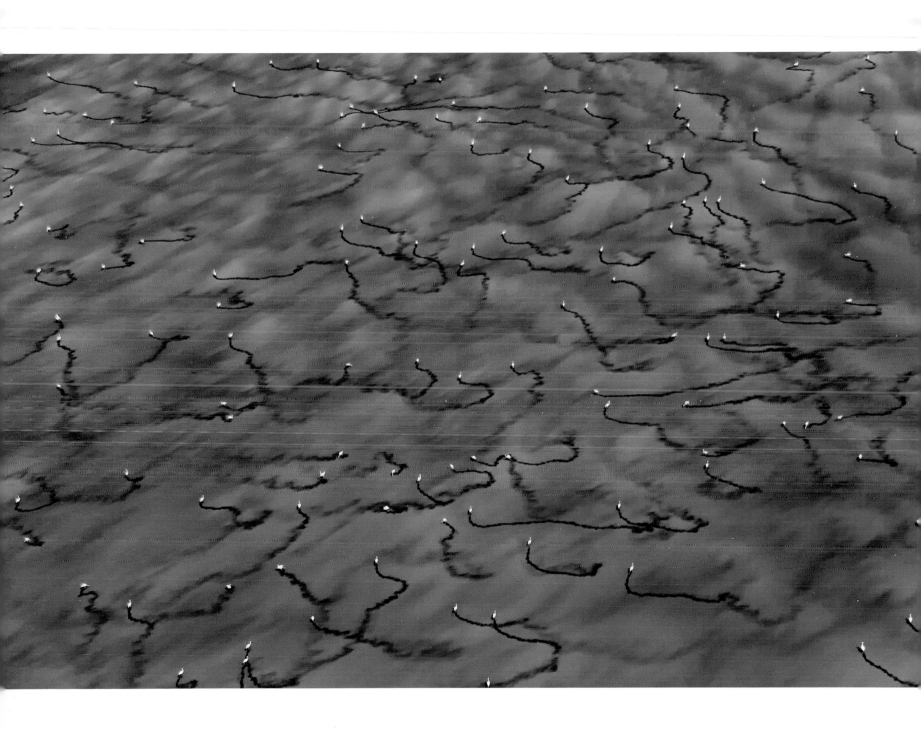

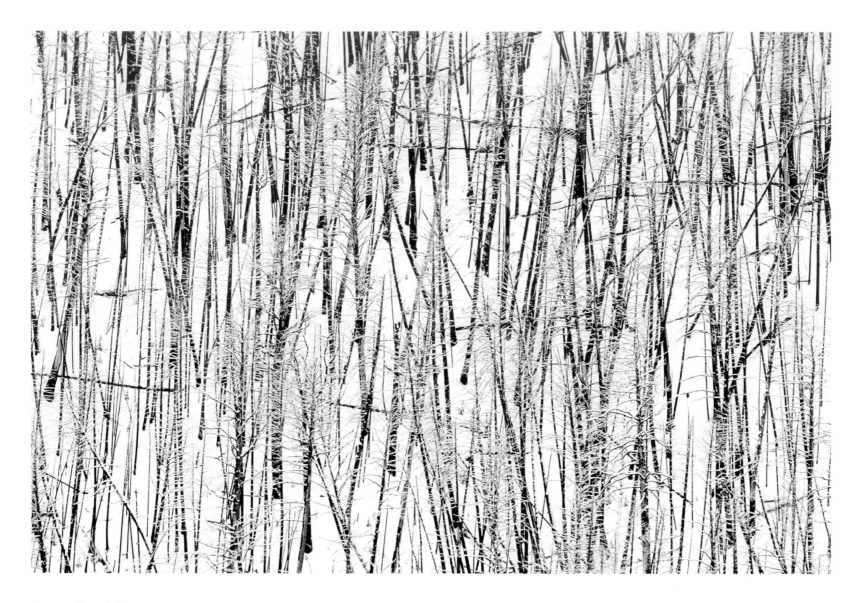

Scorched beauty

Amy Gulick

USA

Amy photographed this scene in Yellowstone National Park, Wyoming, 15 years after the largest fires in the park's history burnt more than a third of its forest, mainly lodgepole pines. The crisscross weave of fire-blackened trunks set against a canvas of snow has a stark beauty. But there is a hidden beauty, too, of renewal. Most lodgepole pines are fire-dependent, producing cones that open up only when subjected to fire, releasing their seeds onto a forest floor open to the light. And in Amy's image, in the gaps between the trunks, young pine trees are evident. The Yellowstone fires were an inevitable event, fuelled by drought and following a long history of fire suppression. 'By drawing people in with a beautiful abstract,' explains Amy, 'I hope they might start to think about the role natural fire plays in shaping the health of this ecosystem.'

Nikon F4 + 600mm f4 lens; Gitzo tripod + Arca-Swiss head; Fujichrome Velvia.

Natural frame
Morkel Erasmus
SOUTH AFRICA

Morkel could hear every rumble. He could even smell the elephants. But his view was limited to the viewing slit of a cramped bunker sunk into the ground beside a remote waterhole in Namibia's Etosha National Park. Giraffes, zebras and kudu wandered in and out of view, but the elephants were right in front, sometimes so close that his view was blocked. Morkel used black and white to place the emphasis on the composition. His moment came when a mother framed his shot with her legs just as her calf walked into view framing a giraffe. Having caught his 'dream moment', Morkel put down his camera and just sat and enjoyed the 'bliss' of watching wild animals taking their turn to drink from this life-giving waterhole.

Nikon D800 + 70-200mm f2.8 lens at 200mm; 1/640 sec at f8; ISO 360.

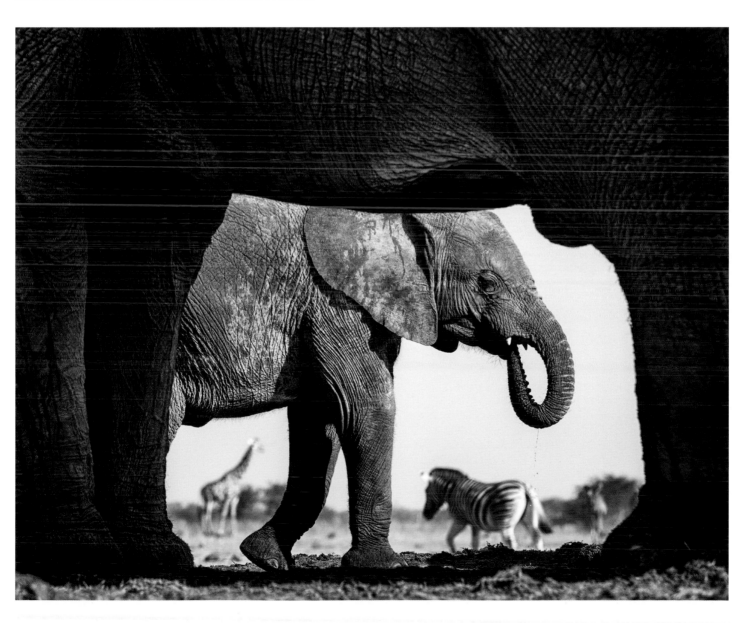

Impressions

Life comes to art

Juan Tapia

SPAIN

Every year, a pair of barn swallows nests in the rafters of an old storehouse on Juan's farm in Almeria, southern Spain, entering the building through a broken windowpane. Equipment and tools are kept in the building, but the swallows seem unperturbed by people coming in and out. Last spring, Juan decided to try to take a very different picture of the swallows. He first had to find the right painting to use as a prop – in the end choosing one familiar from his childhood. Making a swallow-sized hole in the oil painting, he moved it over the window that the swallows entered through. When the pair first arrived, they flew straight in through the window, unperturbed by the canvas. But rather than risk disturbing the birds that spring, he waited until the following spring to set up the shot. Using two flashes, both to light the canvas and to freeze the movement, he linked a remote control to his camera, which he positioned to shoot the entrance hole against the sky. He then retreated to his truck with his binoculars ready. He had no trip beam, and so it took 300 shots and 8 solid hours before he finally got the moment one of the swallows swooped in with the sky behind, as though it had punched straight through into another world.

Canon 7D + 70-200mm f2.8 lens at 150mm; 1/250 sec at f14; ISO 400; Canon 580EX II and Metz 58 flashes; x2 Metz photocells; Manfrotto tripod + Rótula RC2; Godox remote.

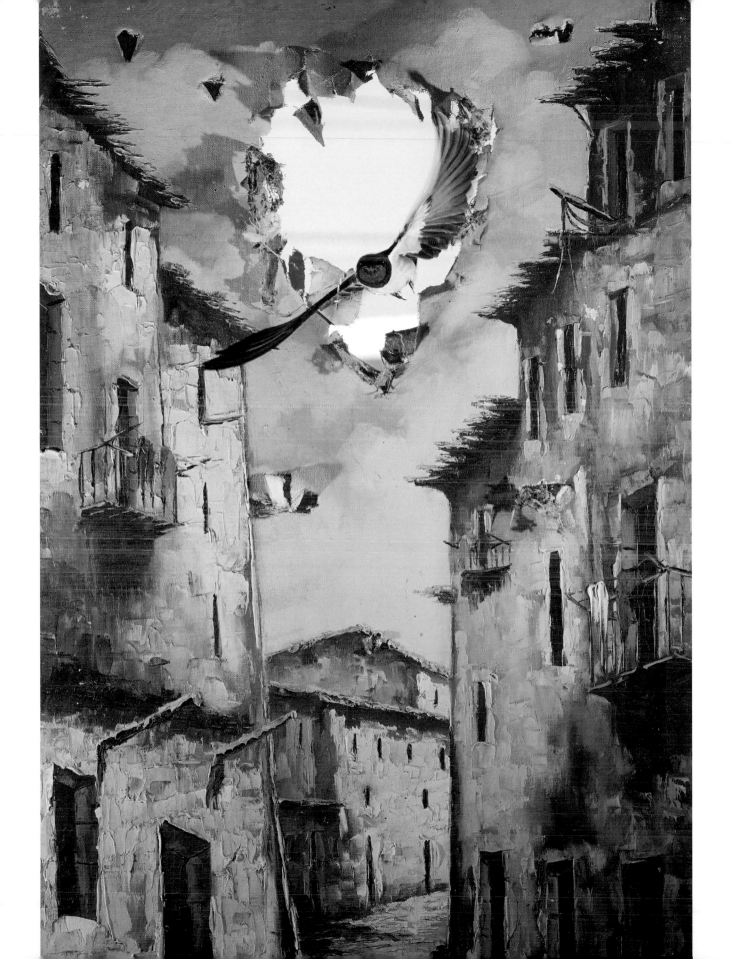

Coastal colours
Jens Rosbach
GERMANY

The intense turquoise of the sea off Fuerteventura in the Canary Islands, contrasting with the sky and sand, inspired Jens to create this painterly image. Standing in the winter sunshine on Corralejo Nature Reserve's sandy beach, he watched the waves break over the coral reef. 'I wanted to condense the impression of largeness, freedom and relaxation by the sea,' he says. For five years, he had been using a 'camera in motion' technique, involving a long exposure and sliding a hand-held camera along the horizon. 'People think I'm mad when they see me swinging my camera back and forth,' he says, 'but for one remarkable picture, I have to take hundreds of shots.' In this case, he used white-crested waves against the dark coral, and the cold blue sky opposing the warm brown sand as visual frames to maximise the effect of the rich turquoise.

Canon EOS 5D Mark III + 24-105mm f4 lens at 80mm; 1/20 sec at f22 (-0.3 e/v); ISO 50.

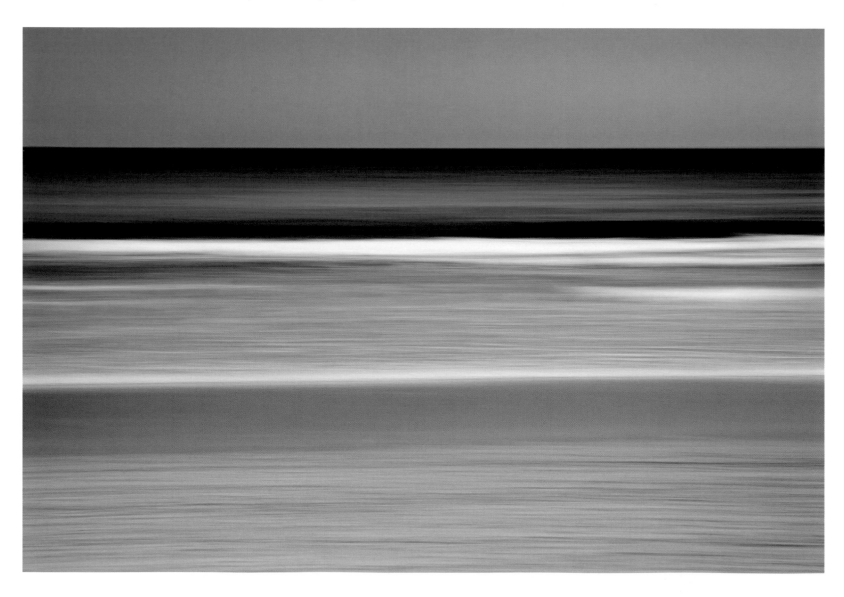

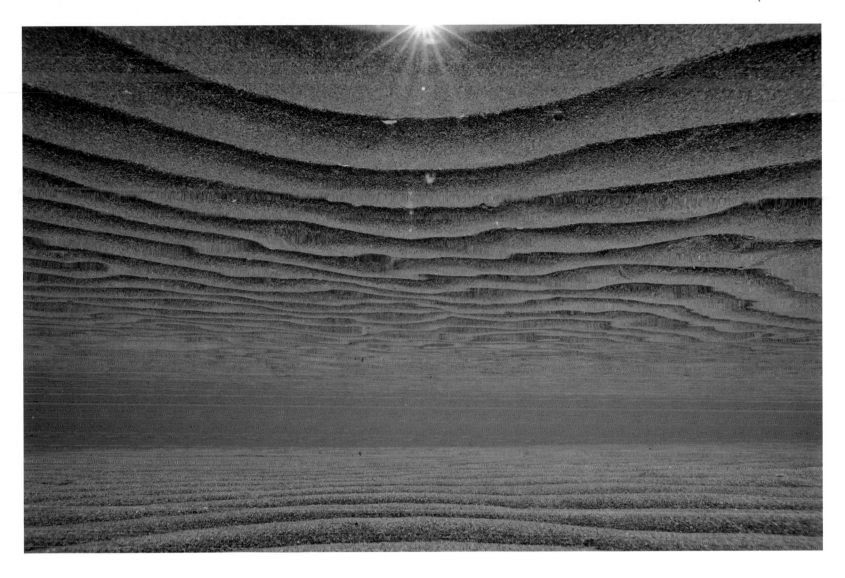

Ripple design
Angel M Fitor

SPAIN

The story Angel wanted to tell was how basic elements interact to shape a landscape – how heat from the sun generates wind that creates waves and currents, which leave their designs in the sand. In the lagoon of Mar Menor in southeast Spain, he scouted in the shallows for 'the right pattern, with the right orientation'. Waiting for the perfect light as the sun went down, Angel set his camera to get a slightly upwards perspective in the shallow water. To capture a mirror-still reflection of the ripples on the surface, he triggered the camera remotely to avoid any vibrations. Luckily, there wasn't a breath of wind, and he was able to make the image he had in mind. 'It is a simple story, made of simple elements,' says Angel, 'but in a way, it represents the whole story of our planet.'

Nikon D800 + Sigma 20mm f1.8 lens; 1/125 sec at f22; ISO 1600; Anthis Nexus housing + dome; Retra Underwater Technology uTrigger.

Ice design
Hugo Wassermann
ITALY

Hugo had gone to Lake Dürrensee in South Tyrol, Italy, at the end of autumn –
as he often did – specifically in search of frozen designs. Overnight, 'the wet
mud around the lake freezes into a work of art,' he says, 'and you find lots of
beautiful details and structures.' On this occasion, rain during the day created
new layers of ice over the already frozen lakeshore surface, and every morning
Hugo was treated to a new array of designs. He spent two hours photographing
this frozen arrangement of grass and reeds. His idea was to frame 'a small
painting' and use an 'in-camera' double exposure to achieve the effect he
wanted. Between taking two pictures with identical settings, he moved the
tripod very slightly, creating the painterly brush-stroke effect.

Canon EOS 5D Mark III + 100mm f2.8 lens; 1/5 sec at f16; ISO 200; Gitzo tripod.

The texture of life
Juan Jesus Gonzalez Ahumada
SPAIN

'I became fascinated by the similarity in texture between the skin of a chameleon and the surface of a leaf,' says Juan, who set out to create a semi-abstract image with a natural fusion of these forms. He lives in Andalusia, in southern Spain, where Mediterranean chameleons thrive. They are well camouflaged in bushes and trees, with strong grasping feet and prehensile tails, though when on the ground, they are vulnerable to road-kill and predation. On a mid-February morning, conditions were perfect: the sun was shining but the temperature was still cool and the chameleons sluggish as a result. Using a large wigandia leaf (an introduced South American plant) with a natural hole, Juan set up his tripod to frame it against the light under a bush where a chameleon was stationed. After a long wait and moving the leaf slowly a great many times, he eventually captured the moment when one of the chameleon's eyes is visible through the hole. Chameleons have very sharp eyesight and each eyeball can move independently. Here it's swivelling one eye down to check what was happening, the shadow of its body taking on the vein pattern of the leaf.

Canon EOS 6D + 100mm f2.8 lens; 1/60 sec at f7.1; ISO 200; Manfrotto tripod.

The Wildlife Photojournalist Award: single image

Broken cats
Britta Jaschinski
GERMANY/UK

Locked into obedience by their trainers' gaze, big cats perform at the Seven Star Park in Guilin, China. They have had their teeth and claws pulled out, and when not in the arena, they live in the tiny cages visible behind the stage. At least one (centre) is a captive-bred hybrid – part lion, part tiger. In 2010, the Chinese authorities issued a directive to zoos and animal parks to stop performances that involve wild animals. But this is not legally binding, and in many facilities across the country, it is still business as usual, with shows attracting audiences unaware of the scale of the abuse, neglect and cruelty involved. For the past 20 years, Britta has travelled extensively, documenting the world of animals in captivity and their unnecessary suffering in the name of education and entertainment. But never, she says, has she come across 'such brutal and systematic deprivation' as in China. 'The potential for change is huge,' she maintains. 'Despite government control of the internet, social-media messages do get through and can make a difference. Attitudes are changing.'

Nikon F4 + 24mm lens; 1/125 sec at f5.6; Kodak Tri-X-Pan 400 black-and-white film.

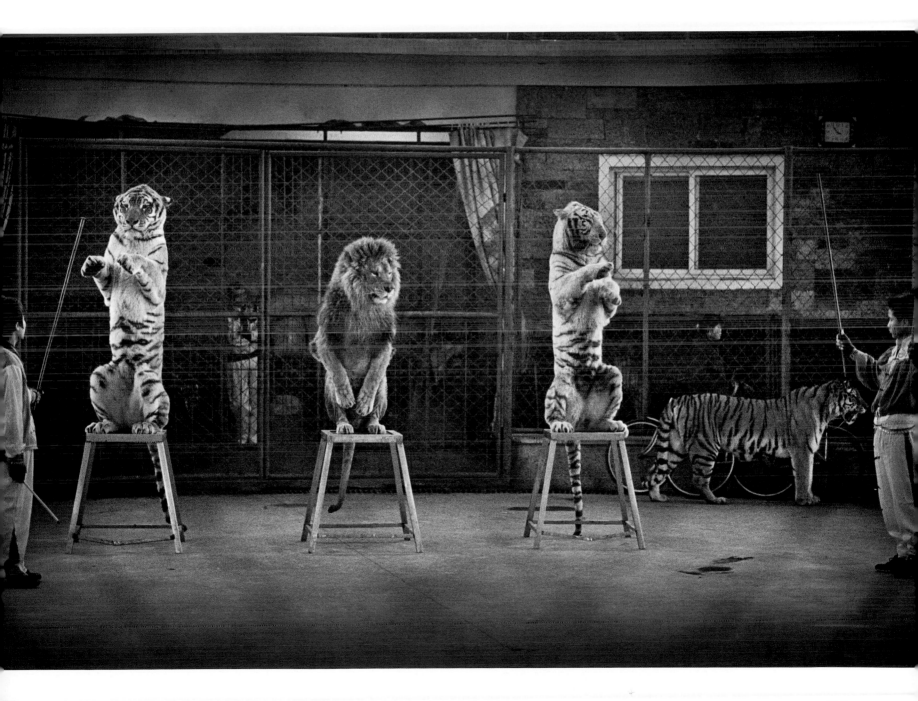

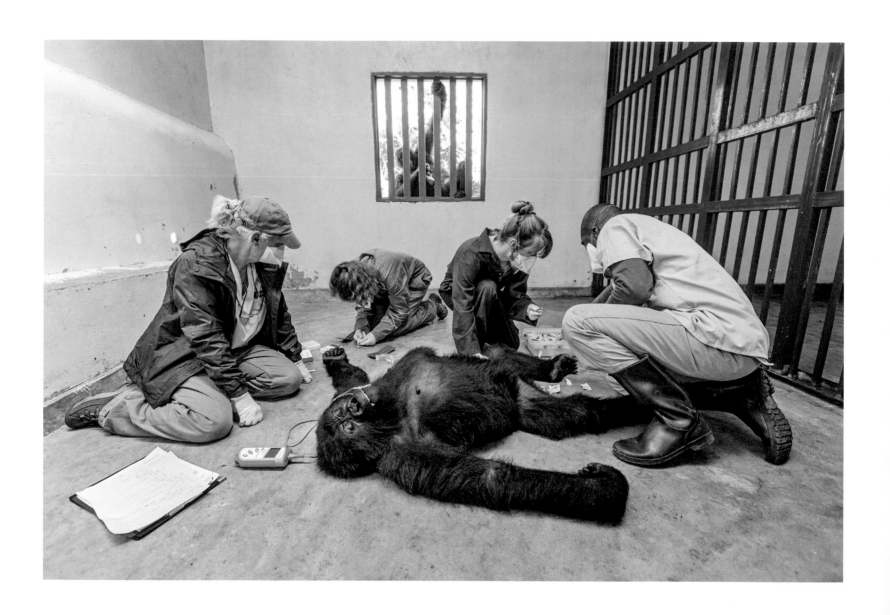

Gorilla care

Marcus Westberg

SWEDEN

Ndeze, a nine-year-old orphan mountain gorilla, watches with concern as veterinarians check the health of her female companion, twelve-year-old Maisha, in the Senkwekwe Centre at the headquarters of the Virunga National Park, in the Democratic Republic of the Congo. The resident 'gorilla doctor' Eddy Kambale (here with the former regional director Jan Ramer, left, assisted by two visiting vets) runs thorough health checks every year on the four orphan mountain gorillas, all of whom have been rescued from poachers and traffickers and have suffered traumatic experiences. The centre – named after Ndeze's father, who was murdered along with Ndeze's mother and several other members of her family in 2007 – is just part of the park's efforts to protect the surviving mountain gorillas. 'The deep bonds that exist between these orphans, their carers and Eddy is one of the most touching things I have ever had the privilege of witnessing,' says Marcus.

Canon 5D Mark III + 16-35mm f2.8 lens at 16mm; 1/80 sec at f4.5; ISO 1600.

End of the line for tuna

Karine Aigner

USA

It's early morning, and the fish market at Japan's Katsuura Port is in full swing. Staff are preparing hundreds of longfin tuna, laid out on the bloody concrete of an open processing area, severing their heads and tails, and gutting and tagging them for immediate auction. Karine took advantage of a stairwell to take an overhead shot of the macabre line-up of the bodies of these once living, warm-blooded fish – among the fastest in the ocean. They are also among the most sought-after. Though there are catch-quotas for the species, there is concern that longfin tuna may become overfished. Together with the most prized of all – the endangered bluefin tuna – the longfin tuna is listed on the International Union for Conservation of Nature's (IUCN) 'Red List' of species threatened with extinction, mainly because of the demand for sushi and sashimi.

Canon EOS 5D Mark III + 24-70mm f2.8 lens at 53mm; 1/250 sec at f2.8; ISO 1250.

The shark surfer
Thomas P Peschak
GERMANY/SOUTH AFRICA

The many sharks to be found at Aliwal Shoal near Durban, South Africa, make it a popular dive site – the perfect place to test a prototype surfboard with an electromagnetic shark deterrent. Surfers are occasionally targeted by sharks, but the risk of attack is very low. In 2014, there were 72 unprovoked shark attacks on swimmers worldwide, only 3 fatal. But fear of sharks prevails, and gill nets are still used to kill sharks in the hope of reducing attacks. 'I wanted to illustrate a non-lethal approach to mitigating the shark-surfer conflict,' explains Tom. When the new board was switched off, the curious blacktip sharks swam close, but when it was activated – stimulating their sensory organs – they stayed at a distance. To avoid bubbles in the picture, Tom free-dived, framing the complementary forms to suggest peaceful coexistence rather than conflict.

Nikon D700 + 16mm lens; 1/1600 sec at f18; ISO 500; Subal housing.

Chained to tradition
Emily Garthwaite

UK

An Asian elephant stands visibly traumatized, chained to a temple pillar in Varanasi, northern India. She had endured a six-hour procession through the narrow city streets, amid thousands of cheering onlookers, brought as a blessing in the build up to Diwali (the festival of lights). The Asian elephant – a highly intelligent and very social species – is of great cultural importance in India, said to be one of the nine jewels (navratnas) that surfaced when the oceans were churned by the gods and demons in search of immortality. Today, in the wild, it's endangered. Emily watched 'as children played between the chained legs of the terrified elephant, locals pulled on her tail for luck and fireworks rocketed around her body. She caught her trunk in the knotted mass of overhead wiring, once fell to her knees (a man jabbing her neck until she got up), was given no water and was fed nothing but a few rupee notes.' Emily waited for a gap in the crowd to make her poignant image, using only the dim light of a street lamp. 'The elephant was swaying,' she says, 'and her bloodshot eyes swirled, as her owner looked on anxiously. He said she was going "mad" and he didn't understand why.'

Canon EOS 5D Mark III + 50mm f1.8 lens; 1/125 sec at f1.8; ISO 3200.

The Wildlife Photojournalist Award: story

The award is given for a story told in just six images, which are judged on their story-telling power as a whole as well as their individual quality.

Brent Stirton

SOUTH AFRICA

Ivory wars: from the frontline

Elephant poaching is one of the most lucrative black markets in the world. A kilo of raw ivory can fetch more than $2,000, and a small (6–10 kilogram/13–22 pound) elephant tusk $12,000–$20,000 or more. Up to 154 metric tons of ivory are trafficked out of East Africa every year. Between 2010 and 2012 alone, a fifth of the world's wild savannah elephant population – more than 100,000 elephants – were poached, and two thirds of forest elephants were killed in the past decade. At a conservative estimate, 25,000–35,000 elephants are killed every year. Brent set out to focus international attention on the people who are profiting most – not terrorists, as is often reported, but notorious rebel groups within Africa – and draw attention to those at the sharp end of the ivory war, the rangers who risk their lives to try to stop the killing, often with precious little support from the outside world.

The spoils of war

Michael Oryem, until recently an active Lord's Resistance Army (LRA) soldier, holds tusks from a consignment of ivory he has led the Ugandan Army to. This ivory was taken in Garamba National Park in the Democratic Republic of the Congo (DRC) and then buried over the border in the Central African Republic (CAR) on its way to the headquarters of the notorious LRA. When he was nine, Michael was abducted from his Ugandan village by the LRA – the rebel group responsible for killing thousands of people in Uganda, South Sudan, CAR and the DRC. Seventeen years later, he defected. His testimony – that he had been commanded to kill elephants in the Garamba National Park and trade the ivory with the Sudanese army for supplies and weapons – is evidence of the direct connection between poaching and the LRA. Without access to lucrative ivory, the LRA would be considerably weakened.

Canon EOS-1D X + 24-70mm f2.8 lens; 1/250 sec at f16; ISO 200.

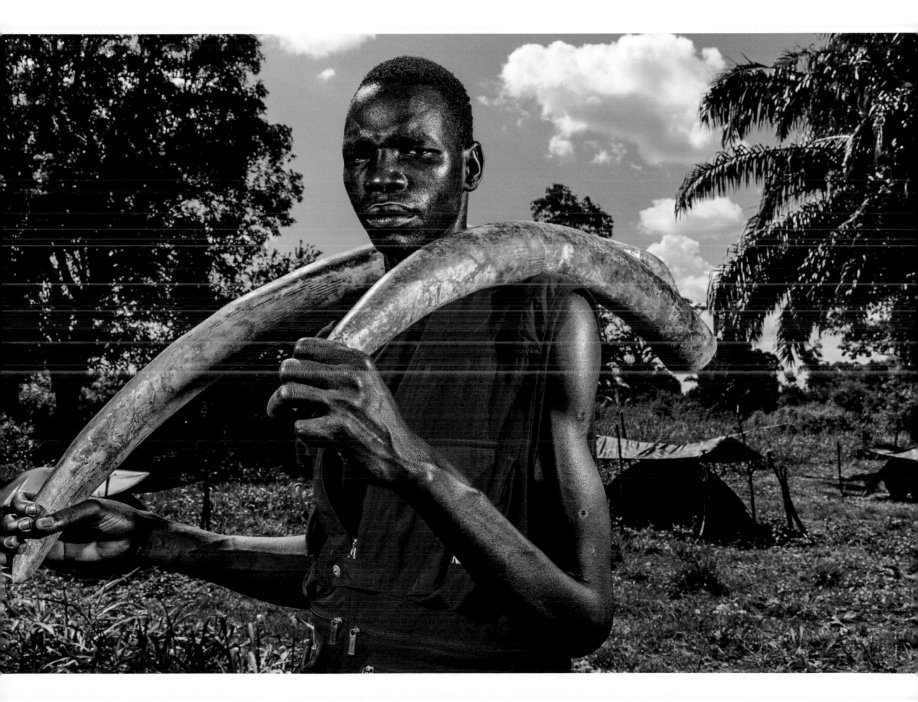

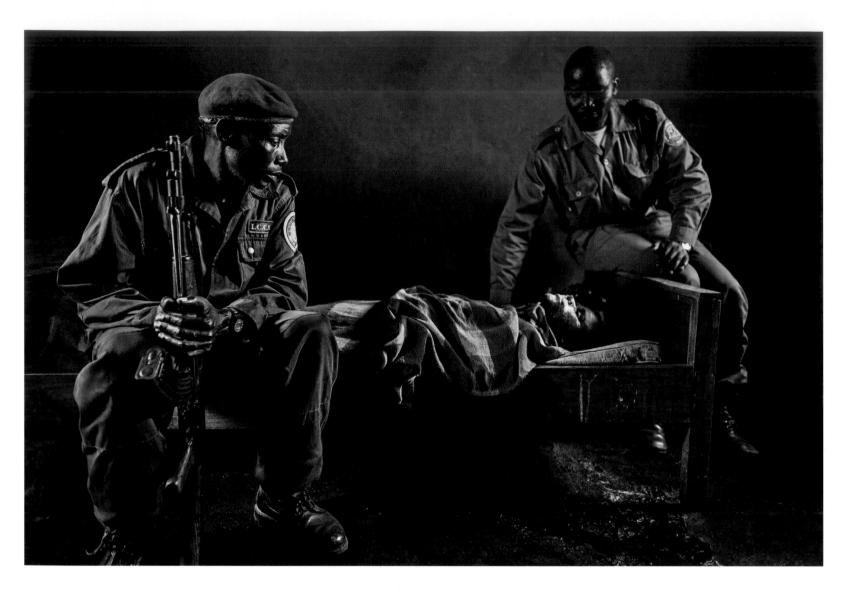

The price they pay

Kambale Bemu lies dead, shot five times at point-blank range just two hours before. A ranger in the DRC's Virunga National Park, he was bringing rations to the park's Ishango substation when he was killed by a rebel Congolese-army soldier. Kambale was one of more than 160 rangers killed in the past 10 years while protecting the park's exceptional wildlife, many at the hands of the Rwandan rebels from the FDLR (Forces Démocratiques de Libération du Rwanda). The group fled into the park after the Rwandan genocide of 1994 and has caused havoc ever since, poaching elephants for ivory to finance its campaigns. In 2010, two years after Kambale's death, his close friend and colleague Masimengo Kanguru (left) retired after a long period risking his life for the park. Atamato Tsa (right) stayed on. In 2013 he, too, was murdered. The top pay for a ranger is no more than $200 a month.

Canon EOS-1D X + 24-70mm f2.8 lens; 1/80 sec at f1.8; ISO 400.

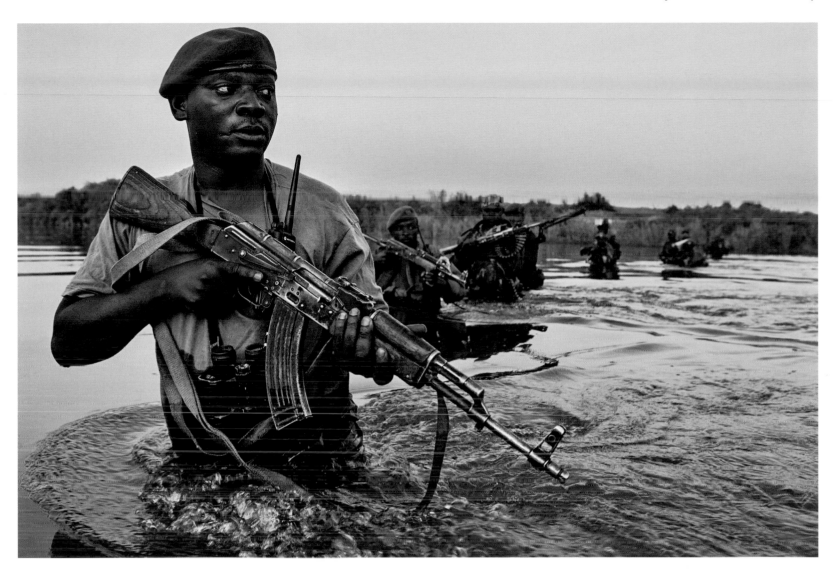

In the firing line

Rodrigue Katembo, a charismatic, passionate conservationist, leads a patrol of Congolese rangers and soldiers through a dangerous area of the DRC's Virunga National Park in search of poachers who have killed two elephants. Twenty minutes after crossing the river, they came under sustained fire from the FDLR. Every time a patrol goes out, the men face danger from these Hutu-led rebels, who have inhabited the park since they fled Rwanda in 1994, causing mayhem and destruction. The park, a World Heritage Site, protects a critically important population of mountain gorillas, elephants, okapis and chimpanzees. It's also one of the most dangerous places in the world to practise conservation. Following his role in an undercover investigation into illegal oil exploration, Rodrigue has since been transferred out of Virunga for his own safety following imprisonment, torture and death threats from members of the Congolese military.

Canon EOS-1D X + 24-70mm f2.8 lens; 1/160 sec at f6.3; ISO 400.

Ivory widows

Bernadette Kahindo and her family are victims of the ivory trade. Her husband, Assani Sebuyori, was a dedicated ranger in the DRC's Virunga National Park, trying to stop the ivory and bushmeat trade conducted by the notorious FDLR Rwandan militia. But in 2012, the rebels ambushed Assani's park vehicle and murdered him, leaving his decapitated body as a warning to other rangers. Bernadette has seven children to support, including her daughter Gift (left), whose baby is the result of her being raped at 14. The family survives on a tiny widow's allowance, supplemented by donations from supporters of the Virunga National Park.

Canon EOS-1D X + 24-70mm f2.8 lens; 1/100 sec at f9; ISO 400.

Ivory haul

Police officers in Lomé, the capital and main port of the West African country of Togo, guard one of four confiscated shipping containers containing elephant tusks. The haul, at Lomé's deepwater harbour, was the result of a vigilant customs officer spotting tusks in one of the many containers passing through his scanner. DNA evidence linked some of the ivory to a massacre in the Central African Republic (CAR) in 2013, when anti-government Séléka rebels climbed the observation towers at the famous Dzanga Bai saltpan viewing site in Dzanga-Ndoki National Park and gunned down 26 elephants. This find confirmed the direct link between ivory poaching and violent political upheavals in CAR and that the port was being used as a new route for smuggling ivory out of Africa. At this stage of the trafficking pipeline, it would be the middlemen who would suffer a loss of revenue. The rebels would already have got their proceeds, used to fuel more of the violence that plagued CAR in 2013 and 2014.

Canon EOS-1D X + 24-70mm f2.8 lens; 1/125 sec at f14; ISO 200.

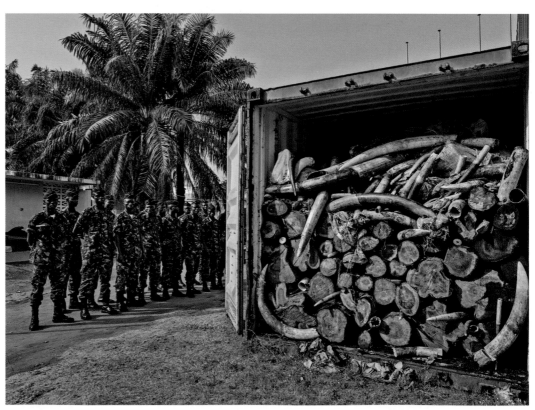

Survivors

The largest surviving herd of elephants in Chad's Zakouma National Park, numbering around 400, moves out of the bush at the end of the day, going to drink at a river pool close to the headquarters of the park. In 2002, there were at least 4,300 elephants in the park. By 2011, severe poaching meant there were only about 450 – the family groups mainly gathered together in one big herd for security, too stressed to breed. Publicity for the crisis, including a major *National Geographic* feature, attracted international funding and donations, and the acquisition of a dedicated aircraft. A change of management, support from President Idriss Déby and initiatives such as equipping local nomads with two-way radios have transformed the park. Not a single elephant has been poached in nearly three years, and the elephants are breeding again. Tourism has also restarted. This is proof that, with funding and commitment from those on the ground, it's possible to protect elephants from the poachers.

Canon EOS-1D X + 24-70mm f2.8 lens; 1/640 sec at f8; ISO 400.

The Rising Star
Portfolio Award

This award seeks to inspire and encourage photographers between the ages of 18 and 25 and is given for a portfolio of work.

Connor Stefanison

CANADA

All but one of Connor's portfolio images were taken in his home province of British Columbia on the west coast of Canada, all but one with a wide-angle lens, placing the subject within its wider environment. Connor is in love with wild places and the excitement of revealing, through photography, intimate moments or new perspectives on natural events. Encouraged by winning this same award in 2013, while still at university, studying ecology and conservation, Connor is now working as a professional photographer, aiming to concentrate on photojournalism.

Raven strut

Thick, fresh snow covered the summit of Mount Hollyburn and carpeted the hemlock trees, and fog hung in the air. The conditions were perfect for landscape photography. But what Connor was there for were the ravens. The mountain, overlooking Vancouver, is a popular winter hiking area, accessible on snowshoes. The ravens know that people rest at the summit and eat food there, and so they watch for hikers and the promise of scraps. Connor's difficulty was waiting for one to alight on an area of snow free of snowshoe footprints and with the right background. Two ravens entertained him for half an hour as they prospected for food. Then finally one of them landed in the perfect spot and performed, walking across the pristine snow, displaying its characterful strutting gait.

Canon EOS 5D Mark II + 16-35mm f2.8 II lens at 16mm; 1/1000 sec at f7.1; ISO 1600.

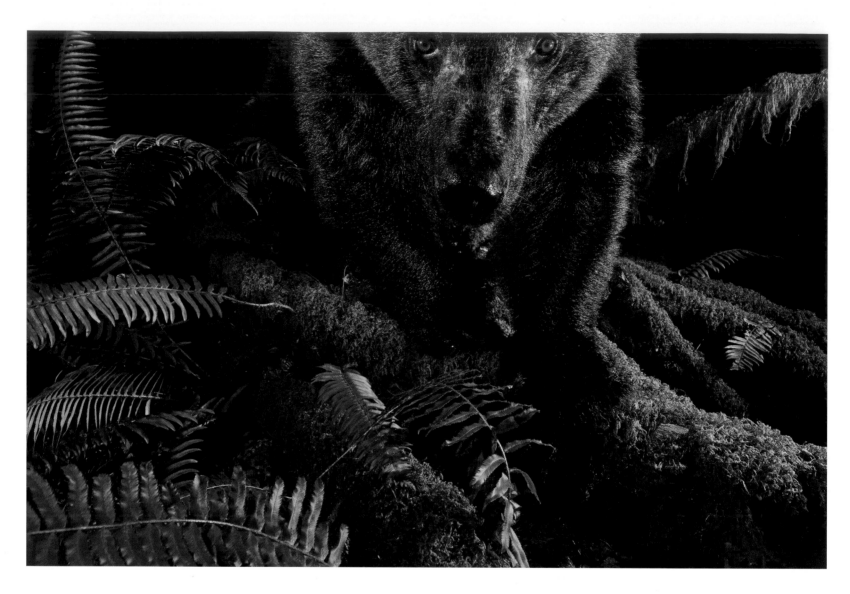

A black bear looks in

Connor set out to photograph a western spotted skunk. He had already taken several camera-trap shots of skunks – evidence that the near-vanished species was still present in British Columbia, his home province – and now he wanted a portrait image to help with a conservation initiative. He also wanted a background that would illustrate the lushness of the coastal rainforest environment. Setting up his equipment in forest not far from Maple Ridge, among sword ferns and the moss-covered roots of vine maples, he placed a small bit of meat in front of the beam – not enough to interest a black bear, he reasoned. He certainly didn't want to attract one, as they are highly curious and notorious for destroying camera traps. After a week of nothing, he returned to check the camera and was disheartened to see a bear scat on the path. But his gear was still intact. Relief then turned to delight when he realized that not only did he have an image of a black bear but that it had stared directly into the camera.

Canon Rebel XTI + Tokina 12-24mm f4 lens at 15mm; 1/200sec at f9; ISO 400;
Trailmaster 1550-PS infrared trail monitor; x2 Nikon SB-28X2 and Nikon SB-800 flashes.

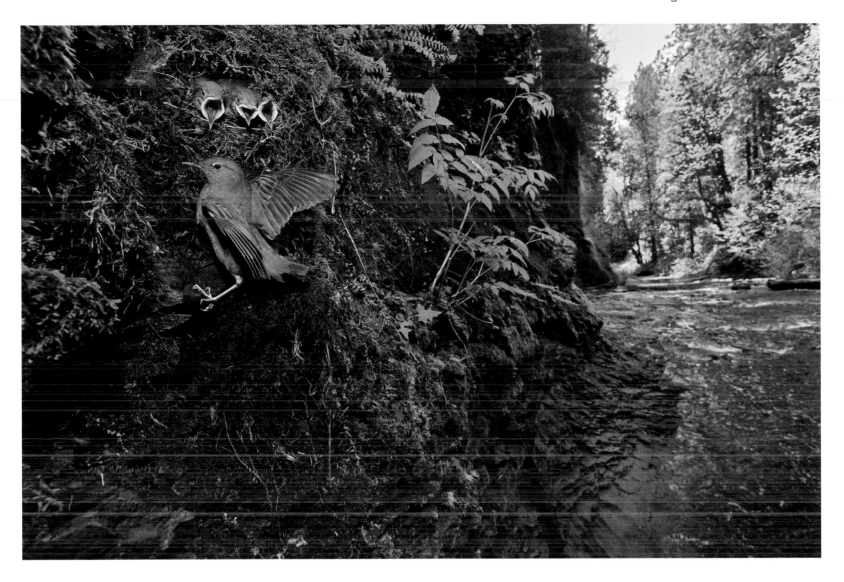

Creekside nursery

The picture shows a female American dipper that has just delivered a beakful of invertebrates to her demanding chicks in their riverbank nest. The most difficult aspect of the shot was setting up the equipment without disturbing the nesting birds. Connor did it gradually, one item at a time, wading to and fro across the river near Maple Ridge, British Columbia. Another challenge was assembling the equipment on a slippery rock without losing anything into a deep pool of water immediately below. He then got the dippers used to the camera, clicking the shutter before using any lights, though the sound would almost certainly have been masked by that of the rushing water. Key to the picture was the lighting. He used two flashes, each with a diffuser to give a gentle pulse of light that wouldn't disturb the family. But just as important was the sunlight illuminating the river scene behind, which helped place the nest in the context of the dippers' riverine feeding ground.

Canon EOS 5D Mark II + 16-35mm f2.8 II lens at 22mm + polarizing filter; 1/60 sec at f13; ISO 1600; Yongnuo YN-560 II and Nikon SB-800 flashes; Vello wireless remote; tripod.

Aerial buffet

In spite of a face mask and gloves, Connor was still getting bitten, and it was difficult to resist swatting the ravenous mosquitoes away. Standing in a freshwater marsh near Williams Lake, British Columbia, he was photographing black terns as they foraged after sunset. Using a wide-angle lens and a flash to light the insects as well as the birds, his aim was to reveal that black terns carry on feeding after dark. He soon realized that some were swooping closer, not just for territorial reasons but also taking advantage of the thick cloud of mosquitoes clustered around him. Connor had become a part of the interaction he was photographing.

Canon EOS-1D Mark IV + 16-35mm f2.8 lens at 16mm; 1/60 sec at f8; ISO 2500; Canon 580EX II flash.

Hot-spring skeletons

Eerie skeletons emerge from the sulphurous steam of geothermal pools at Mammoth Hot Springs in Yellowstone National Park, Wyoming, USA. The dead trees have been glued into place by calcium carbonate mineral deposits, which also create constantly changing terraces of travertine. Heat-loving microorganisms tint these into a tapestry of colour. To create the ghostly abstract he had in mind on a photographic return trip to the springs, Connor needed to exclude the sky. He'd brought an extra-large tripod, but in the end, he had to stand on a big rock to get the height, angle and perspective he needed.

Canon EOS 5D Mark II + 70-200mm f2.8 IS lens at 200mm + B+W polarizing filter + Vello cable release; 10 sec at f16; ISO 200; Gitzo GT3541XLS tripod.

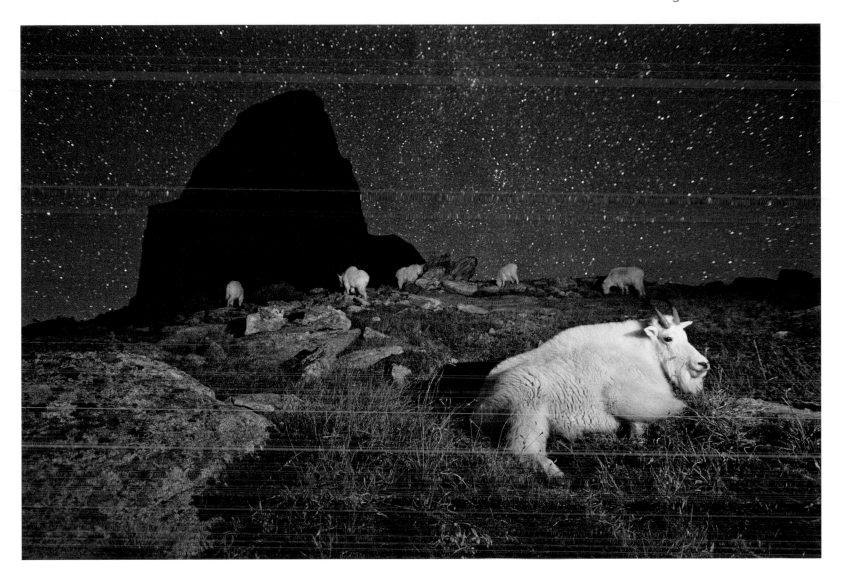

Night of the mountain goats

It was a clear, starry night, which is what he had hoped for, but with barely any moonlight, framing the mountain goats had to be a matter of guesswork. The dominant billy goat had just lain down for a short rest a few metres away, and so this was the moment for an image. It was late September, and the goats were already growing their thick winter coats. They had descended from their daytime grazing area in the heights of British Columbia's Selkirk Mountains to feed on the flatter ground. This was where Connor had camped for three days, to allow the goats to get used to his presence. In fact, they were so accustomed to him that one brushed past as he was photographing another. Now, framing a shot was the problem. Connor used a long exposure for the stars and a gentle manual flash, first to light the billy goat, then again for the rest of the herd grazing behind, keeping his fingers crossed that the goat wouldn't move for the 25 seconds he needed.

Canon EOS 5D Mark II + 16-35mm f2.8 lens at 16mm + Vello cable release; 25 sec at f4; ISO 3200; Canon 430EX II flash; Gitzo GT3542LS tripod.

The Young Wildlife Photographer of the Year 2015

The Young Wildlife Photographer of the Year 2015 is Ondřej Pelánek— the winning photographer whose picture has been judged to be the most memorable of all the pictures by photographers aged 17 or under.

Ondřej Pelánek

CZECH REPUBLIC

 Ondřej was given a small compact camera when he was eight and quickly became a keen nature photographer, shooting insects and other animals near his home in the Czech Republic. Wanting to know the names of the creatures he had photographed, Ondřej started using field guides. Now, at 14, he is a knowledgeable naturalist – winner of his region's 'biological olympic games' three years in a row. He is also an accomplished bird artist.

WINNER (11 TO 14)

Ruffs on display

Snoring was all Ondřej could hear – from his father, who had fallen asleep in the hide. The ruffs displaying in front of him were silent. The hide that Ondřej and his father had erected was on the Norwegian Varanger Peninsula, beside a traditional ruff lek – an open grassy area where males stake out small display arenas into which they attract females and which they defend against other males. It was midnight, but being the Arctic summer, the sun was above the horizon and there was enough light to photograph by. And as the ruffs were displaying all through the night, Ondřej and his father were taking it in turns to rest, except that Ondřej was so excited that he couldn't sleep. Ten males were puffing up their ruffs and head tufts and strutting around their small territories, keeping rivals at bay. As females were present, the display activity had increased. Ondřej's winning shot captures the moment when one male has lunged forward and leapt up to assert his territorial rights over another nearby male. (See also page 146.)

Nikon D800 + 300mm f2.8 VR II lens + TC-20E III; 1/500 sec at f7.1 (-1 e/v); ISO 4000.

Young Wildlife Photographers:
10 and under

Summer days
Carlos Perez Naval

SPAIN

European bee-eaters are among Carlos's favourite birds. There is a colony near his grandmother's village of Castrojeriz in Burgos, northern Spain, and every summer, he visits it. The nests are in a sandy bank near a small river and beside a path, where he sets up his home-made hide and settles down to watch. The bee-eaters catch dragonflies from the river as well as bees, wasps and butterflies. When they bring food to their mates or feed their chicks, they often perch on this one branch before entering their nest holes. To take his winning shot, he arrived first thing in the morning, before the light was too intense and it was not too hot. He wanted to frame one perching and one flying in the same shot, which meant waiting and being ready for the moment. Carlos loves the breeding colours and songs of bee-eaters, and they remind him of long summer holidays with his grandmother.

Nikon D7100 + 200-400mm f4 lens + 1.4x extender at 550mm; 1/1250 sec at f5.6; ISO 500; tripod; hide.

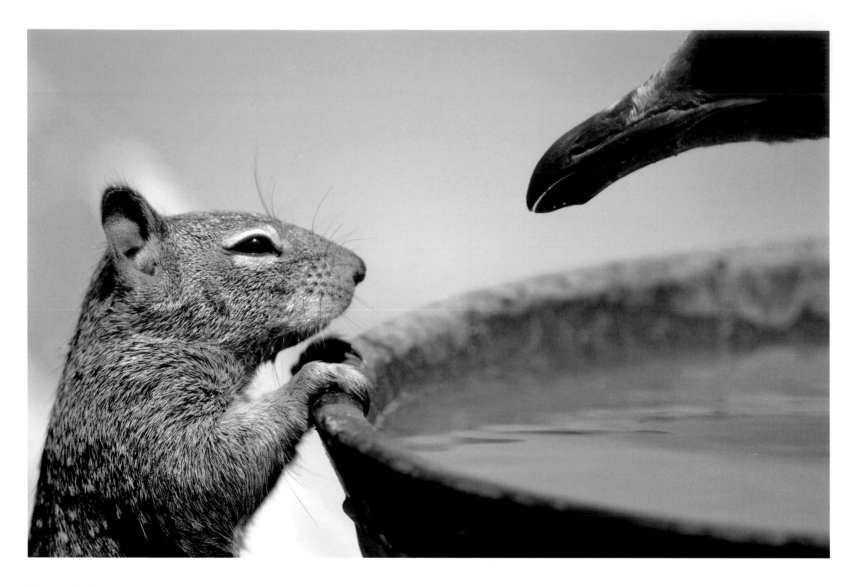

To drink or not
Carlos Perez Naval

SPAIN

Carlos was down on the beach at Morro Bay in California, on holiday with his family, when he witnessed a fascinating interaction between two different species. A colony of California ground squirrels lives among the rocks at one side of the bay, fed by locals, who also put out dishes of water for them. What Carlos noticed was that western gulls were monopolizing the water. Whenever a ground squirrel dared to get too close, a gull would chase it away, aiming its powerful beak at the squirrel's head. Carlos was fascinated by the way the ground squirrels would try to sneak in for a sip when the gulls weren't looking. Here, the two competitors' eyes lock over the coveted fresh water. Carlos took the shot just before the gull lunged forwards and the squirrel fled.

Nikon D7100 + 200-400mm f4 lens at 400mm; 1/2500 sec at f5; ISO 500.

Mosquito lookout

Laura Albiac

SPAIN

On a bright winter's day, nine-year-old Laura was birdwatching at Llobregat Delta near Barcelona, Spain, when she noticed this chiffchaff busy hunting mosquitoes from a perch. Chiffchaffs are almost indistinguishable from willow warblers in the field, unless you hear their repetitive 'chiff-chaff' song, but dark legs can be a clue – hence the old saying 'chiffchaff riffraff with dirty legs'. Clinging to a reed in front of the observatory, it kept watch, and each time it spotted a mosquito, it would fly out, grab it, then go straight back to its perch. 'The bird was so small and moving so quickly that it was difficult to focus,' says Laura. With a fast shutter speed and a wide aperture to blur the background, she persevered and captured this atmospheric portrait.

Canon EOS 7D + 100-400mm f4.5-5.6 lens at 380mm; 1/800 sec at f5.6; ISO 400.

Goose attack

Josiah Launstein

CANADA

On a cold February morning, while photographing ducks and geese on a lake in British Columbia, Canada, Josiah noticed a Canada goose behaving very aggressively. It was a little before the usual breeding season, but this individual had clearly staked out its territory and didn't want any intruders. 'It would call loudly and rush out at any other goose that swam by,' says Josiah. 'It even flew up to deter geese that were coming in to land.' Native to North America (but now also common in parts of northern Europe, where it was introduced as an ornamental and game species), the Canada goose typically mates for life, and pairs stay together year round. Josiah climbed down from the pier with his tripod to be at goose level. 'I had just got my lens focused on it,' he says, 'when it exploded out of the shallows at another goose.' With quick reactions, he captured the drama. 'I love how you can see the water and mud flying,' he says.

Nikon D7100 + 300mm f4 lens + 1.4x teleconverter; 1/640 sec at f7.1; ISO 720; Gitzo tripod.

Snowy scene
Josiah Launstein
CANADA

Josiah loves photographing owls. The more elusive snowies are some of his favourites, 'especially the males, because they are so white'. Every year snowy owls arrive from further north to overwinter on the Canadian prairies and can be found near where Josiah lives in southern Alberta. He and his family are keen owl spotters. On this occasion, an unexpected snowstorm lasted the whole day, making conditions almost impossible for photography. After nine hours, they finally spotted a few owls in the blizzard. 'I couldn't believe it when this male flew towards us and caught a vole,' Josiah recalls. Unusual among owls, snowies hunt mainly during the day, locating prey (mostly small mammals but sometimes larger animals such as young hares and birds) by both sight and sound. Josiah's hands were freezing in the −30˚C (−22 ˚F) windchill temperature, but when the owl landed on a fence, he quickly framed his shot through the open truck window and grabbed a few pictures before the owl flew off. Cropping the image to make the most of the 'cool old fence', he neatly captured the elegant bird in its windswept environment.

Nikon D7100 + 300mm f4 lens + 1.4x teleconverter; 1/320 sec at f6.3 (+1 e/v); ISO 3200.

Young Wildlife Photographers: 11–14 years old

Ruffs on display
Ondřej Pelánek

CZECH REPUBLIC

On their traditional lek ground – an area of tundra on Norway's Varanger Peninsula – territorial male ruffs in full breeding plumage show off their ruffs to each other, proclaiming ownership of their courtship areas. Ondřej took his winning shot as one male leapt up, warning off his neighbours. Ruffs are unusual in that breeding males behave according to their plumage colours. Those with dark plumage perform on territories. Ones with white ruffs, known as satellite males (far left and far right), don't hold territories but display on the outside of the lek or form uneasy alliances with territory-holding males, helping them to entice females in the hope of grabbing a sneaky mating if the opportunity arises. A third type of 'sneaky male' disguises itself as a female. (See also page 138.)

Nikon D800 + 300mm f2.8 VR II lens + TC-20E III; 1/500 sec at f7.1 (-1 e/v); ISO 4000.

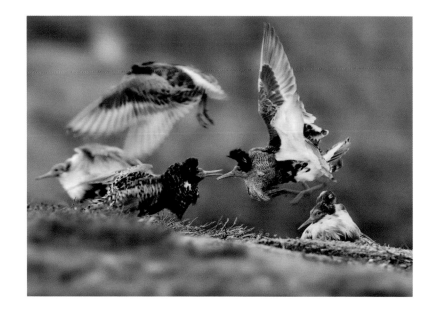

On safari
Jef Pattyn

BELGIUM

Crossing a track in Kenya's Maasai Mara National Reserve was a thick black ribbon, 10 centimetres (4 inches) wide and many metres long: thousands of safari ants on the march, looking for a new nest site. Guarding the flanks were larger soldier ants, rearing up aggressively. Jef lay down to get a better look at their massive heads and pincer-like mandibles, only to discover just how good they are at their job. He would manage just a couple of frames at a time before leaping away in pain as the soldier ants clamped their pincers onto his skin.

Canon EOS 7D + 100mm f2.8 lens at 100mm; 1/30 sec at f5.6 (+0.6 e/v); ISO 800.

Mama's back
Ashleigh Scully
USA

Two fox cubs smother their mother with excited greetings when she returns to the den site. Ashleigh, aged 12, was on a photography course in Grand Teton National Park, Wyoming, when she spotted the cubs romping around in a clearing close to her cabin. Creeping outside with her tripod, she started to photograph them. After a while, their mother appeared from out of the trees. She looked exhausted, remembers Ashleigh. The moment the cubs saw her, they bounded over to greet her, licking her fur, nuzzling her face and mouthing her gently with their teeth. 'There was so much affection between them.' They were moving around so fast, and the light was so variable, that she had to just focus on the vixen and use a high speed. Ashleigh has already photographed many foxes and has already sold a book of her fox photos to raise money for conservation locally.

Canon EOS 5D Mark III + 500mm f4 lens; 1/640 sec at f4.5; ISO 1250; Gitzo tripod + Wimberley head.

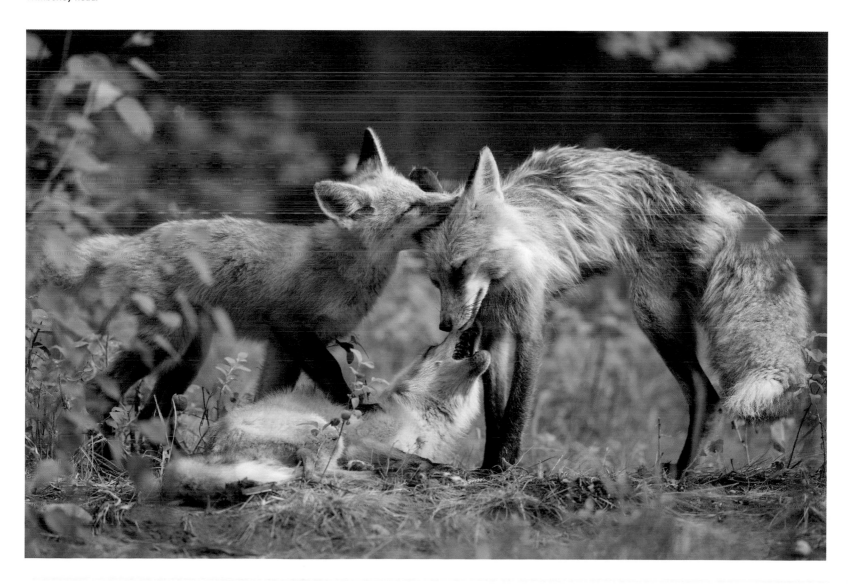

The stare of a goshawk
Liina Heikkinen

FINLAND

Liina and her father arrived at their forest hide near her home in Kouvola, Finland, while it was still dark. They placed a road-kill red squirrel a few metres away, hoping to attract predators, and then retreated to the hide for the day. As dawn broke, the birds began to stir, and jays, great spotted woodpeckers and crested tits filled the forest with calls and activity. Then just as the sun rose enough to light the snow in front of the hide, an adult male goshawk swooped down, picked up the squirrel and landed right in front of the hide. For the next hour, it fed on the carcass, tugging off strips of flesh. In the middle of its meal, it paused and, for a brief moment, stared straight at the hide – an unforgettable moment in an unforgettable day, says Liina.

Nikon D3 + 300mm f2.8 lens; 1/640 sec at f5.6; ISO 800; tripod; hide.

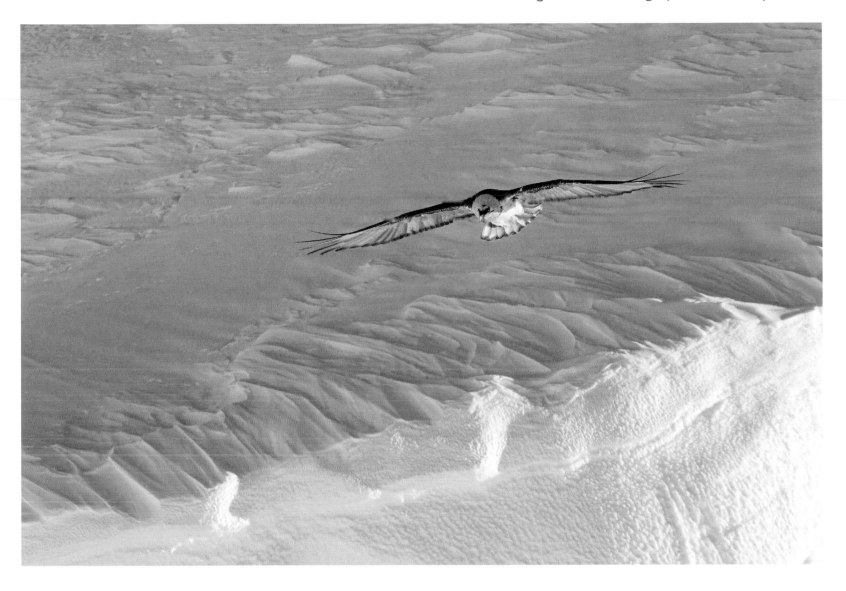

Alpine glider
Louis Pattyn

BELGIUM

Distant glimpses was all Louis had had of lammergeiers – bearded vultures – after two days trying to photograph them as they scoured the steep slopes of the Bernese Alps, looking for carrion. On this morning, Louis and his dad were on a mountain ridge near the Swiss Gemmi Pass and had already spent several hours watching and waiting. It was bitterly cold, with a biting wind. But when a huge lammergeier came into view, its wingspan some 2.5 metres (8 feet), Louis managed to get his frozen fingers to work and catch the magnificent vulture as it glided by, illuminated by the low winter sun.

Canon EOS 7D + 100-400mm f4.5-5.6 lens at 190mm; 1/2000 sec at f8; ISO 400.

Young Wildlife Photographers: 15–17 years old

Flight of the scarlet ibis

Jonathan Jagot

FRANCE

Jonathan has been sailing round the world with his family for five years, and for the past three years he has been taking wildlife photographs. It was when they anchored off the island of Lençóis on the coast of northeast Brazil that he saw his first scarlet ibis – the most beautiful birds he had ever seen. He discovered that at high tide they roosted in the mangroves and that at low tide they flew to the mudflats to feed on the crustaceans and shellfish with their probing curved beaks. He learned their favourite feeding spots and when to expect them. But they were very nervous, and so he had to be careful not to get too close, and the pictures of them on the mudflats or in the mangroves were never quite right. Then he had an idea: he would photograph a flock framed against the beautiful dunes that the island is famous for. At low tide, he took his dinghy into an estuary at one end of the island, anchored where he had a view of the dunes and waited. As the tide rose, so did the ibis, creating a glorious pattern of scarlet wings against the canvas of sand and tropical blue sky.

Nikon D5100 + 55-300mm f4.5-5.6 lens at 300mm; 1/1000 sec at f6.3; ISO 360.

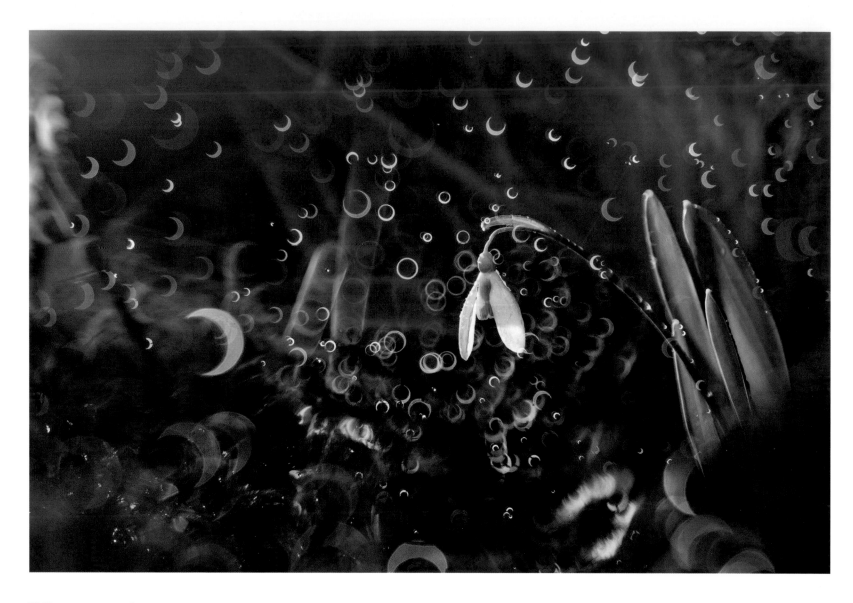

Winter magic
Etienne Francey

SWITZERLAND

Etienne had been itching to use his macro lens all winter. 'It opens the door to the imagination,' he explains. He just hadn't found the right subject, until snowdrops appeared on a bank near his home in Fribourg, Switzerland. 'I love their simplicity, and how they bloom so early, unafraid of the cold,' he says. It was getting dark by the time he had finished his homework. 'I didn't have long,' he recalls. 'It was freezing and the light was fading – almost every photo was giving a different result.' He sprayed water to enhance the blurred areas and partly covered the lens with a circle of paper to create the moon flares. Adjusting the white balance to enhance the blues and using an incandescent filter on the flash, he created an atmospheric image in celebration of this special winter flower.

Nikon D800 + 150mm f2.8 lens; 1/60 sec at f4 (-1.7 e/v); ISO 800; Nikon flash + incandescent filter; Manfrotto tripod.

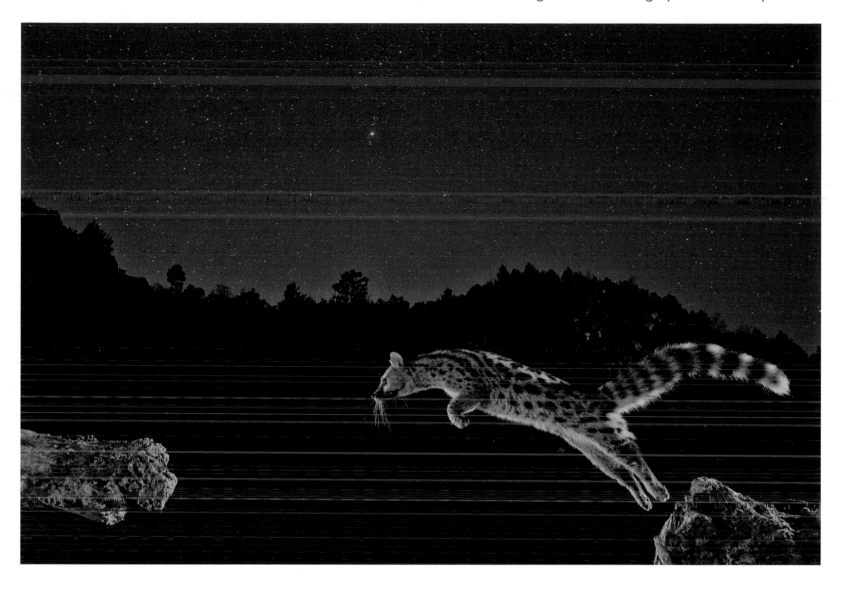

A genet feat of a leap

Marc Albiac

SPAIN

In autumn, Marc, together with two friends and his father, set about discovering where genets might be living near his home in the Serra de Collserola, the Spanish mountains that rise above Barcelona. Having found droppings, they set up a camera trap in a tree near the spot. It revealed that three different genets (with different spot patterns) were using the area. Over the next months, they regularly put out food at the location so the animals would become used to human scent. By March, this energetic genet was at ease with Marc's presence as it hunted for rodents. Working out where it was likely to go, he put a little food on a pile of logs and set up his tripod. Using a double exposure (with a flash to freeze the genet as it jumped from a rock to the logs and a long exposure for the stars), he took the genet's portrait placed against a backdrop of the starry sky.

Canon EOS 5D Mark III + 17-40mm f4 lens; 15 sec at f4; ISO 1600; x4 flashes; tripod.

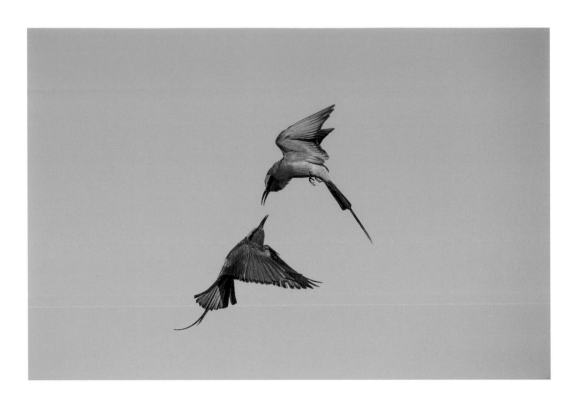

Battle of the bee-eaters
Juan van den Heever
SOUTH AFRICA

When Juan witnessed a fight between two southern carmine bee-eaters on his third day at Katima Mulilo, Namibia, he challenged himself to capture a close-up of the action before the end of his trip. Thousands of these colourful birds nest in the banks of the Zambezi River in huge colonies. Juan watched as the males swooped around trying to impress the females, with inevitable squabbles breaking out. 'The speed and sheer number of birds was overwhelming,' he says, 'and it was very difficult to focus. I frequently got cramps in my upper body from swinging the heavy lens back and forth looking for shots.' These two males repeatedly flew at each other, using their bills to 'joust like fencers with swords', each ducking just in time. With determination and a fast shutter speed, Juan finally froze one moment of the contest.

Nikon D4 + 200-400mm f4 lens; 1/4000 sec at f7.1; ISO 1000.

Golden catch
Thomas Villet
FRANCE

'I wanted to capture this splendid bird in the most beautiful moment of the day,' says Thomas. So, he spent all afternoon and evening digging a hole beside a lake near where he was staying in central France, to give himself an eye-level view facing the rising sun. Every morning for a week, he went at dawn and waited (his feet under water), hoping that a great egret would walk out into the lake and fish between the hide and the sun. The first few days were cloudy, but on the fourth, conditions were perfect – 'it looked as though the pond had been set on fire,' says Thomas – and the bird obliged. Selecting a wide aperture 'to get as much of the incredible light as possible', he created this evocative picture of a great egret about to toss and swallow its crayfish catch.

Canon EOS 7D + 300mm f2.8 lens; 1/4000 sec at f2.8 (-1.7 e/v); ISO 100; Manfrotto tripod; hide.

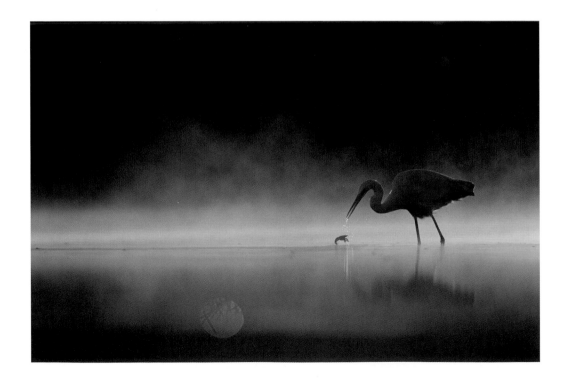

The TimeLapse Award

This is given to a sequence of still images lasting 45–90 seconds
that tells a story, captures a dramatic moment or paints a creative tableau.

www.nhm.ac.uk/ghosts-and-castles

Ghosts and castles
Tobias Bernhard Raff
GERMANY

Under cover of darkness, as the tide rolls out, ghost crabs emerge for
a frantic bout of feeding. They also cover the beach with 'sandcastles'.
These excavation mounds are produced as they dig out new daytime
shelters – spiral shafts into which they will retreat when the tide rolls
back in, protecting them from predators and the sun. Tobias moored his
boat in New Caledonia's Southern Lagoon and spent a week observing
and recording the ghost crabs' nocturnal activities. He used time-lapse to
depict both their industriousness and their relationship with the tides, the
challenge being to light the scene without disturbing them and to keep
track of where the crabs would pop up again when the tide went out.

GoPro 4 + f2.8 lens + 4x dioptre lens; 1 frame per 5 sec; ISO 400; GorillaPod;
Premiere Pro to output. Nikon D800 + 16-35mm f8 lens at 24mm; 1 frame per 5 sec;
ISO 400; Subal housing; Manfrotto tripod; x3 LED lights + Manfrotto monopods;
Premiere Pro to output.

Dartmoor moods
Guy Richardson and Alex Nail
UK

Dartmoor National Park is the largest, wildest area of open country in
Southwest England, encompassing dramatic granite tors, high open moorland,
ancient woodland and torrent rivers. It's also steeped in history – geological,
ecological and human. Alex and Guy have been photographing here for many
years and are intimate with its character and moods. Over a full year, they
shot more than 10,000 timelapse stills of its most iconic sites. These were
edited together to produce an original seven-minute production, and then
down once more to one minute for this version, to capture the dramatic
progression of light at different times and seasons and bring to life the
dynamic landscape that they know and love.

Canon EOS 5D Mark II + Nikon D800 + various lenses; x2 Dynamic Perception Stage Zero
dollys + MX2 motion controller; tripods; Adobe Lightroom + LRTimelapse + After Effects;
Premiere Pro to output.

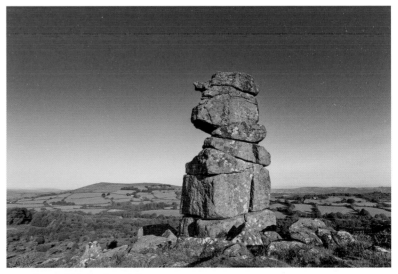

www.nhm.ac.uk/dartmoor-moods

Index of Photographers

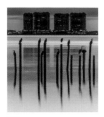

78
Frank Abbott
USA
christop.abbott@gmail.com
www.frankabbott.com

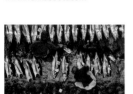

122
Karine Aigner
USA
karine@karineaigner.com
www.karineaigner.com

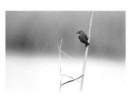

143
Laura Albiac
SPAIN
lauraalbiac@gmail.com
www.lauraalbiac.blogspot.com.es

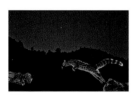

153
Marc Albiac
SPAIN
marcalbiac@gmail.com
www.marcalbiac.blogspot.com.es

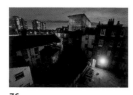

76
Neil Aldridge
SOUTH AFRICA/UK
neil@conservationphotojournalism.com
www.conservationphotojournalism.com
Agents
www.naturepl.com
In South Africa: johna@cjsystems.co.za

103
Ellen Anon
USA
ellenanon@mac.com
www.ellenanon.com

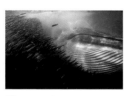

88
Michael AW
AUSTRALIA
one@michaelaw.com
www.MichaelAW.com

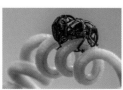

52
Javier Aznar González de Rueda
SPAIN
javiaznar@hotmail.com
www.javier-aznar-photography.com

63
Petr Bambousek
CZECH REPUBLIC
sulasula@email.cz
www.sulasula.com

82, 83
Daniel Beltrá
SPAIN/USA
danielbeltra@yahoo.com
www.danielbeltra.com

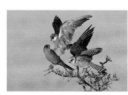

28
Amir Ben-Dov
ISRAEL
amir.bendov@gmail.com
www.amirbendov.zenfolio.com

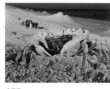

155
Tobias Bernhard Raff
GERMANY
wildimages@hotmail.com
www.tobiasbernhard.com
Agents
www.gettyimages.co.uk
www.corbisimages.com
www.biosphoto.fr
www.photoshot.com

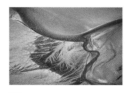

86
Pascal Bourguignon
FRANCE
pascal@decliceditions.com
www.pascalbourguignon.com

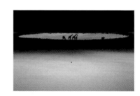

62
Marina Cano
SPAIN
marinacano@photo.net
www.marinacano.com
Agent
fishermike@mac.com

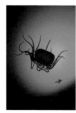

94
Jordi Chias Pujol
SPAIN
jordi@uwaterphoto.com
www.uwaterphoto.com
Agent
www.naturepl.com

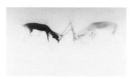

106
Nilanjan Das
INDIA
dasbappa@gmail.com

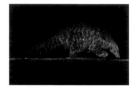

56
Tristan Dicks
SOUTH AFRICA
tristand1986@gmail.com
www.nyamazanephotography.co.za

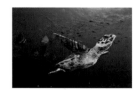

44
David Doubilet
USA
www.daviddoubilet.com

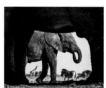

111
Morkel Erasmus
SOUTH AFRICA
morkel@morkelerasmus.com
www.morkelerasmus.com

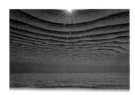

115
Angel M Fitor
SPAIN
seaframes@seaframes.com
www.seaframes.com

152
Etienne Francey
SWITZERLAND
etienne.97@hotmail.com
www.etiennefrancey.ch

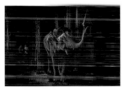

124
Emily Garthwaite
UK
emilygarthwaite@gmail.com
www.emilygarthwaite.com

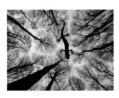

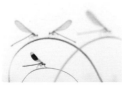

36, 48
Edwin Giesbers
THE NETHERLANDS
info@edwingiesbers.com
www.edwingiesbers.com
Agent
www.naturepl.com

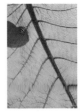

117
Juan Jesus Gonzalez Ahumada
SPAIN
ahumada585@hotmail.com
www.jjgahumada.com

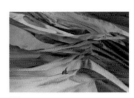

58
Sergey Gorshkov
RUSSIA
gsvl@mail.ru
www.gorshkov-photo.com
Agents
www.mindenpictures.com
www.naturepl.com

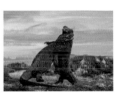

42
Andrey Gudkov
RUSSIA
gudkov2000@mail.ru
www.wildanimalsphoto.com

110
Amy Gulick
USA
amyg@nwlink.com
www.amygulick.com

10, 12, 54
Don Gutoski
CANADA
dgutoski@sympatico.ca
www.pbase.com/wilddon

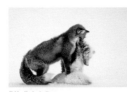

34
Charlie Hamilton James
UK
www.charliehamiltonjames.co.uk

148
Liina Heikkinen
FINLAND
liina.heikkinen@hotmail.com
www.luontokuva.org

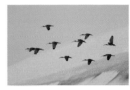

38
David Herasimtschuk
USA
davidherasim@gmail.com
www.davidherasimtschuk.com
www.freshwatersillustrated.org
www.friendsofbenders.org

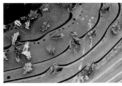

104
Hermann Hirsch
GERMANY
hermann.hirsch@gmx.de
www.hermann-hirsch.de

150
Jonathan Jagot
FRANCE
worldtravelerjohn@hotmail.fr

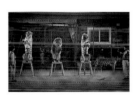

118
Britta Jaschinski
GERMANY/UK
info@brittaphotography.com
www.brittaphotography.com

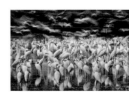

32
Zsolt Kudich
HUNGARY
zsolt@kudich.com
www.kudich.com
hello@kudich-zsirmon.com
www.kudich-zsirmon.com

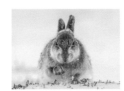

94
Hadrien Lalague
FRANCE
lalague_hadrien@hotmail.com
www.hadrien-lalague.com

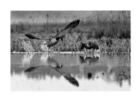

144, 145
Josiah Launstein
CANADA
josiah@launsteinimagery.com
www.launsteinimagery.com

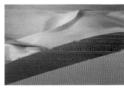

68
Timo Lieber
GERMANY/UK
info@timolieber.com
www.timolieber.com

60
Rosamund Macfarlane
UK
rosamundmacfarlane49@hotmail.com

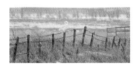

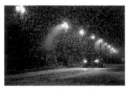

75
José Antonio Martínez
SPAIN
j.a.images@terra.com
www.joseantoniomartinez.com

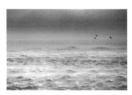

30
Vincenzo Mazza
ITALY
vincestrello@gmail.com
www.vincenzomazza.net

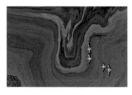

84, 108
Paul Mckenzie
IRELAND/HONG KONG
paulconormckenzie@yahoo.com
www.wildencounters.net

46, 70
Ugo Mellone
ITALY
u.mellone@gmail.com
www.wildphoto.it

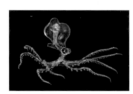

96
Fabien Michenet
FRANCE
fmichenet@yahoo.fr
www.nuditahiti.com

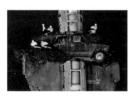

74
Francisco Mingorance
SPAIN
jfranciscomingorance@gmail.com
www.franciscomingorance.es

155
Alex Nail
UK
alex@alexnail.com
www.alexnail.com

69
Laszlo Novak
HUNGARY
nl@novaklaszlo.hu
www.novaklaszlo.hu

27
Heike Odermatt
THE NETHERLANDS
heike@odermatt.nl
www.odermatt.nl

146
Jef Pattyn
BELGIUM
jefpattyn@hotmail.com

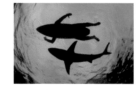

149
Louis Pattyn
BELGIUM
louispattyn1@hotmail.com

138, 146
Ondřej Pelánek
CZECH REPUBLIC
ondrap2@gmail.com
www.phototrip.cz

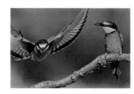

140, 142
Carlos Perez Naval
SPAIN
enavalsu@gmail.com
www.carlospereznaval.wordpress.com

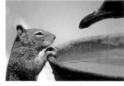

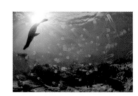

92, 123
Thomas P Peschak
GERMANY/SOUTH AFRICA
thomas@thomaspeschak.com
www.thomaspeschak.com
Agent
www.natgeocreative.com

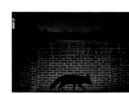

72
Richard Peters
UK
richard@richardpeters.co.uk
www.richardpeters.co.uk

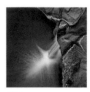

101
Sheldon Pettit
AUSTRALIA
pettit10@netspace.net.au
www.sheldonpettitphotography.com

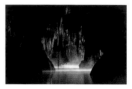

22
Georg Popp
AUSTRIA
georg.popp@popphackner.com
www.popphackner.com
office@popphackner.com

155
Guy Richardson
UK
info@guy-richardson.com
www.guy-richardson.com

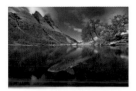

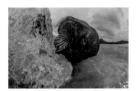

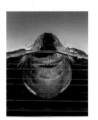

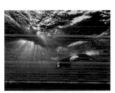

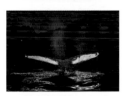

14–21
Audun Rikardsen
NORWAY
audun.rikardsen@uit.no
www.audunrikardsen.com

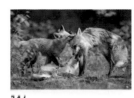

114
Jens Rosbach
GERMANY
info@jensrosbach.de
www.jensrosbach.de

100
Dag Røttereng
NORWAY
dag@naturfotograf.no
www.naturfotograf.no

98
Fran Rubia
SPAIN
frankfhenix23@hotmail.com
www.franrubia.com

147
Ashleigh Scully
USA
awscully12@gmail.com
www.ashleighscullyphotography.com

90
Cristobal Serrano
SPAIN
cristobal@cristobalserrano.com
www.cristobalserrano.com

80
Pere Soler
SPAIN
pere.soler@outlook.com
www.peresoler.smugmug.com

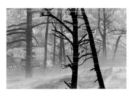

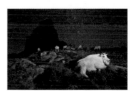

132–137
Connor Stefanison
CANADA
connor_stef@hotmail.com
www.connorstefanison.com

33
David Stimac
USA
dstimac@davidstimac.com
www.davidstimac.com

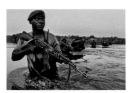

126–131
Brent Stirton
SOUTH AFRICA
brentstirton@gmail.com
www.brentstirton.com
Agent
www.gettyimages.com

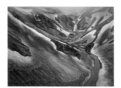

64
Hans Strand
SWEDEN
strandphoto@telia.com
www.hansstrand.com

24, 50
Klaus Tamm
GERMANY
tamm.photography@aol.de
www.tamm-photography.com

112
Juan Tapia
SPAIN
juanicotapia@hotmail.com
www.juantapiafotografia.com

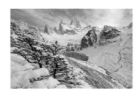

66, 102
Floris van Breugel
USA
floris@artinnaturephotography.com
www.artinnaturephotography.com

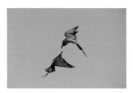

154
Juan van den Heever
SOUTH AFRICA
juan.heever@gmail.com
www.juanvandenheever.com

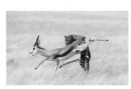

55
Wim van den Heever
SOUTH AFRICA
wim.vandenheever@gmail.com
www.wimvandenheever.com

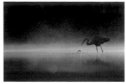

154
Thomas Villet
FRANCE
thomasvillet@outlook.fr

116
Hugo Wassermann
ITALY
hugo.wassermann@gmail.com
www.hugo-wassermann.it

120
Marcus Westberg
SWEDEN
marcus@lifethroughalens.com
www.lifethroughalens.com

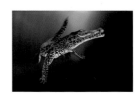

40
Mirko Zanni
SWITZERLAND
mailto@mirkozanni.com
www.mirkozanni.com